The College History Series

UNIVERSITY OF

NORTHERN IOWA
GERALD L. PETERSON

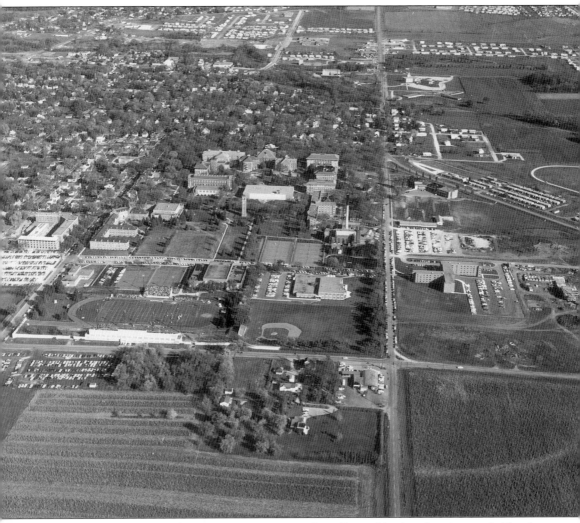

This is an eastern view of the UNI campus in its Cedar Falls neighborhood setting, probably taken in the fall of 1963. The intersection at the lower right is the corner of 27th Street and Hudson Road. Many things have changed since this photo was taken. The farmland in the foreground has disappeared under the UNI Dome and parking lots. The Curris Business Building now covers the tennis courts, Prexy's Pond, and the power plant in the center of the photo. The Speech/Art Complex has replaced the baseball diamond, and the Schindler Education Center and parking lots cover O.R. Latham Stadium in the left center. College Square Mall now occupies the open land at the top right. Despite these changes, the university remains very much a part of its local and statewide communities.

The College History Series

UNIVERSITY OF

NORTHERN IOWA

GERALD L. PETERSON

Gerald L. Peterson

ARCADIA

Published by Arcadia Publishing
Charleston SC, Chicago IL, Portsmouth NH, San Francisco CA

Printed in the United States of America

Library of Congress Catalog Card Number: 00103150

For all general information contact Arcadia Publishing at:
Telephone 843-853-2070
Fax 843-853-0044
E-mail sales@arcadiapublishing.com
For customer service and orders:
Toll-Free 1-888-313-2665

Visit us on the Internet at www.arcadiapublishing.com

I dedicate this book to my parents Victor and Lydia, my brother David, my wife Elizabeth, and my daughters Julie and Amy. Each, in his or her own way, has made it possible for me to write this book.

CONTENTS

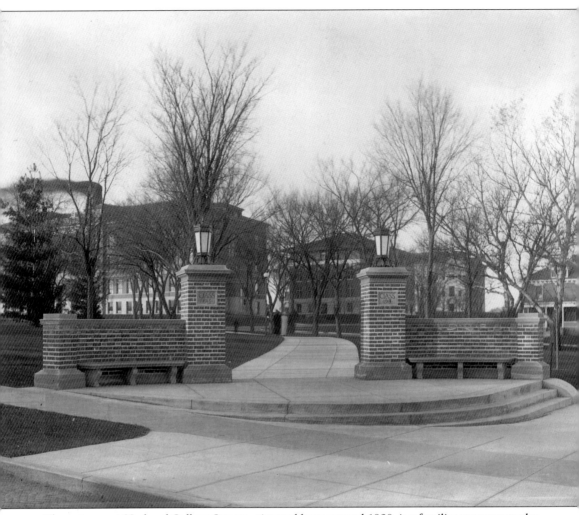

The gateway at 23rd and College Streets, pictured here around 1920, is a familiar entrance to the University of Northern Iowa campus. People have rushed through this area in the midst of their daily activities for generations, but the gateway also represents the door to learning, inspiration, self-awareness, and achievement that the school has opened to countless students in its 125-year history.

INTRODUCTION

The University of Northern Iowa was founded as the result of two powerful forces in nineteenth century Iowa. First, Iowa wanted to care for the orphans of its Civil War veterans. Consequently, Annie Turner Wittenmyer led statewide efforts to build an orphans' home in 1869 on 40 acres of land donated by Cedar Falls citizens. Second, Iowa needed a public teacher training institution, or normal school. Thus, in 1876, when the state no longer needed the facilities of the Cedar Falls Orphans' Home, legislators Edward G. Miller and H.C. Hemenway persuaded the General Assembly to start the Iowa State Normal School on the soon-to-be-vacant site.

James Cleland Gilchrist was the first principal of the Normal School. He and his small faculty developed curriculum, recruited students, and established a solid reputation for the school. Rising enrollment led the state to construct a large second building just six years after the school opened. Unfortunately, Principal Gilchrist's dynamic leadership style led to conflicts with the school's board of directors, and these conflicts resulted in Gilchrist's resignation in 1886.

Homer Horatio Seerley succeeded James Gilchrist. Enrollment grew, and under provision of the state millage tax, the campus began to take shape. The millage (1/10 of 1% of real property evaluation) financed construction of the traditional red brick and limestone buildings on the eastern part of the campus. Despite the success and growing reputation of the school, President Seerley faced continued challenges from 1905 through 1913 when the General Assembly commissioned a series of studies aimed at improving the "efficiency" of Iowa's public institutions. The most serious of these efforts would have limited the school to a two-year curriculum. After an exhausting battle, the state ultimately disavowed this proposed limitation in scope, and President Seerley continued his able and honorable administration until he retired in 1928 after 42 years in office.

The next president, Orval Ray Latham, almost immediately faced the devastating effects of the Depression. Enrollment and state support declined. President Latham also faced critical personnel issues as he attempted to bring faculty credentials up to stricter accreditation standards. Perhaps most notably, President Latham made remarkable progress in developing the campus against the background of crushing economic hardship—he oversaw the building of three dormitories, the commons, and a new power plant.

President Latham's untimely death in 1940 brought Malcolm Price to the presidency. Nearly all of President Price's ten-year administration was devoted to the effects of World War II. During the war, he attempted to carry on traditional college activities while the campus was host to training units of the WAVES and the Army Air Corps. Following the war, he dealt with problems

associated with teaching and housing the returning GIs and their families. After the postwar wave of veterans had passed through the college, President Price resigned and devoted the rest of his career to teaching.

In 1950, James William Maucker became the fifth president of the college. President Maucker oversaw a wide range of changes during his 20-year administration. Shortly after he became president, he dealt with swirling charges and counter-charges of communist influence among the faculty. In the area of curriculum, the college first offered graduate courses in 1952, and in 1961, began to offer non-teaching degrees. The mid-1960s brought the leading edge of the Baby Boom to campus. Facilities and services could scarcely keep up with soaring enrollment. In the late 1960s, the college experienced the full complement of protests and changes associated with the civil rights and anti-war movements. President Maucker handled these challenges with grace, thoughtfulness, and patience, and in so doing, he won the affection and respect of students and faculty alike.

When President Maucker resigned in 1970, John James Kamerick became the school's sixth president. President Kamerick presided over difficult times—tensions left over from the late 1960s, both on and off campus, were still working themselves out, while the school, on tight budgets, attempted to live up to its new university status. Despite these trying circumstances, UNI offered its first doctoral degree and began construction of the Speech-Art Complex during the Kamerick administration.

Constantine W. Curris, who succeeded President Kamerick in 1983, continued his predecessor's efforts to strengthen the university by paying special attention to effective administration, strategic planning, and the university's public image. During his 12-year administration, President Curris dealt with problems associated with continued enrollment growth, particularly in the business curricula, coupled with difficult budget situations.

Robert D. Koob succeeded President Curris in 1995. President Koob's administration has begun to decentralize certain aspects of university operations and to assure that UNI is in the forefront of educational technology.

A distinguished faculty devoted to teaching a rigorous curriculum has supported the strong leadership of the school's eight presidents. The school's first catalogue in 1876 offered a four-year degree, certainly a daunting prospect for a new normal school with a faculty of four. Even when the sole purpose of the institution was the preparation of teachers, the curriculum included strong subject content courses as well as a carefully developed general education sequence. Emphasis on a well-rounded curriculum taught by highly-qualified faculty continues to this day.

Students benefited from their classroom work, but they also profited from what they learned in extracurricular activities such as drama, music, debate, government, and athletics. Most students who entered college were living away from home for the first time; they learned to make adjustments in their responsibilities and expectations. Most discovered ways both to succeed in school and to find time for fun.

This brief pictorial history looks at UNI's first 120 years, with an emphasis on the early and middle years. It is a broad visual survey in a short space, limited sometimes quite simply by the availability of appropriate images. Still, this account offers at least a quick look at what happened as a normal school with 27 students developed into a well-regarded university with an enrollment of over 13,000.

Note: The institution has had four names: the Iowa State Normal School (1876–1909), the Iowa State Teachers College (1909–1961), the State College of Iowa (1961–1967), and the University of Northern Iowa (1967–present). I have used the terms school, college, and university interchangeably, and sometimes anachronistically, in this book.

Gerald L. Peterson
April 1, 2000

8

One

GETTING STARTED

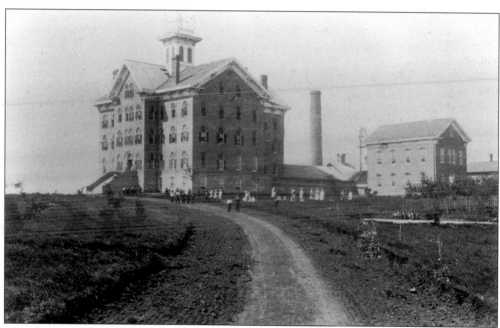

The school's first building, later known as Central Hall, opened in 1869 as a home for orphans of Iowa's Civil War veterans. Annie Turner Wittenmyer led a movement that resulted in the establishment of several orphans' homes around Iowa, including this large building on a 40-acre site donated by citizens of Cedar Falls. When the state consolidated orphanage operations in Davenport in 1876, local legislators Edward G. Miller and H.C. Hemenway persuaded the General Assembly to establish a teacher training institution, or normal school, at the Cedar Falls site.

Central Hall, here standing tall on an isolated prairie hill in 1883, was an impressive sight. The building provided classrooms, common areas, and living quarters for many students, as well as for Principal Gilchrist and his family. But just a few years after the school's founding, Central Hall was overcrowded and needed repair. The stump of the south chimney, on the left, shows the results of an 1882 storm. The building served in many capacities until it was destroyed by fire in 1965.

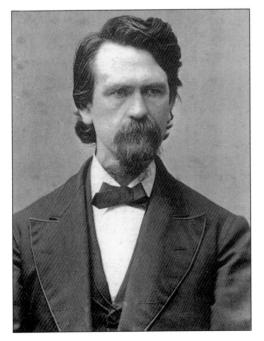

The Normal School Board of Directors selected James Cleland Gilchrist as the school's first principal in 1876. Principal Gilchrist was a tall, striking man and a remarkable orator, teacher, and preacher. He studied under Horace Mann and was involved in normal school work throughout his career. Principal Gilchrist brought high moral and academic standards and boundless energy to all of his work.

Principal Gilchrist and his family initially lived in Central Hall and then in the new classroom building that would later bear his name. Several Gilchrist children attended the school, and Mrs. Gilchrist provided advice, assistance, and comfort to many homesick students. Pictured here in about 1884 are, from the left: son Fred (later a member of Congress), wife Hannah, daughter Norma, daughter Grace, and James Gilchrist.

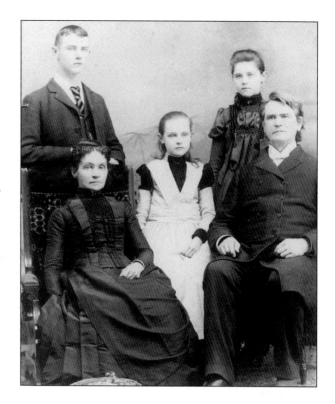

Maude Gilchrist, a daughter of the principal, entered the Normal School in 1876 at the age of 14 and graduated with the first four-year class in 1880. Miss Gilchrist then studied biology at Wellesley before returning to teach at the Normal School in 1883. She resigned in 1886 to continue a distinguished academic career that included teaching and administrative appointments at Wellesley College, MacMurray College, and Michigan State University.

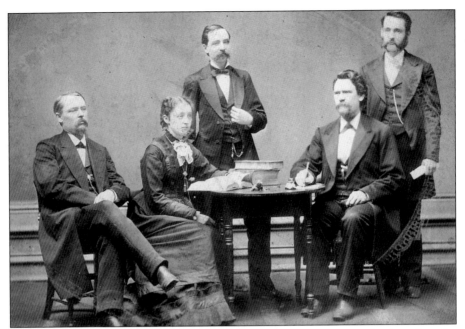

The first Normal School faculty in 1876 included, from the left: Moses Willard Bartlett, Frances Webster, E.W. Burnham, James Cleland Gilchrist, and David Sands Wright. This small band taught rigorous courses of study leading to two-year (elementary), three-year (didactic), and four-year (scientific) degrees. While most early students stayed for only a term or two before leaving to teach, some did persist to achieve degrees.

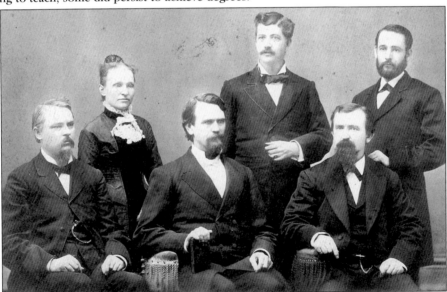

The faculty from about 1880 included, from the left: Moses Willard Bartlett (mathematics and science), S. Laura Ensign (geography and history), James Cleland Gilchrist (philosophy and didactics), J. Monroe Hobron (music), W.N. Hull (elocution and art), and David Sands Wright (language and literature). In an extraordinary display of versatility in 1881, Professors Bartlett and Wright exchanged teaching assignments and continued their new lines of work for the remainder of their long careers.

As this composite photo shows, the faculty and campus had grown by 1886, when Principal Gilchrist resigned. The reasons for his resignation are not entirely clear, but they seem to have centered on his methods of leadership and consequent conflicts with the board of directors. Principal Gilchrist left a prosperous school with a rising reputation to his successor, Homer Seerley.

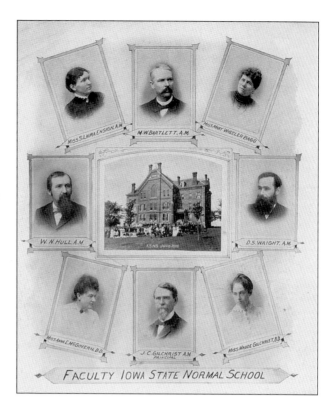

FACULTY IOWA STATE NORMAL SCHOOL

After Anna E. McGovern graduated as a member of the Normal School's first four-year class in 1880, the directors hired her to teach geography. This began a career of distinguished service to the school that lasted until her retirement in 1919. Miss McGovern published in professional journals and was a beloved organizer and leader of the school's Catholic students.

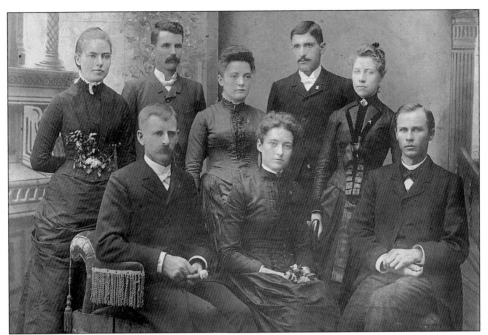

This fourth year class of 1888 includes Charles A. Fullerton, standing second from the left, who became an accomplished member of the school's music faculty. The size of this class demonstrates the small number of Normal School students who thought they needed, or could afford, a four-year degree. Of the 300 students enrolled in 1888, just these eight were seniors.

When state appropriations for a new building fell short, school faculty and Cedar Falls citizens donated over $5000 to finish the project. The building, pictured here on the left and later named Gilchrist Hall, provided badly needed classroom, library, and office space when it was completed in 1884. The Chapel, on the third floor behind the Gothic windows, accommodated large meetings and assemblies. Gilchrist Hall stood east of the current site of the Maucker Union until it was destroyed by fire in 1972.

An observer standing on College Street near the Normal School and looking west in 1891 would have seen this panorama—from the left: Gilchrist Hall, Central Hall, North Hall (or the Old Chapel), and the President's Cottage. The President's Cottage, now the Center for Multicultural Education, survives as the oldest building on campus.

Living in a classroom building was difficult for President Seerley's young family. The new "cottage" pictured here, away from everyday classroom activities, was a welcome relief when it was completed in 1890. The Seerley family poses here in front of their new home in about 1892, from the left: daughter Helen and son Clement on the tricycle, daughter Esther, Homer Seerley, and wife Clara.

In 1889 students petitioned the faculty to institute a military training curriculum. The faculty responded in 1890 with a program of instruction and drill in which nearly all male students participated. Civil War veteran Major William A. Dinwiddie headed the program. Here Governor Boies (left center) presents commissions to smartly-dressed cadets in 1892. The site is the current location of the Rod Library; and the large building in the right background is Central Hall.

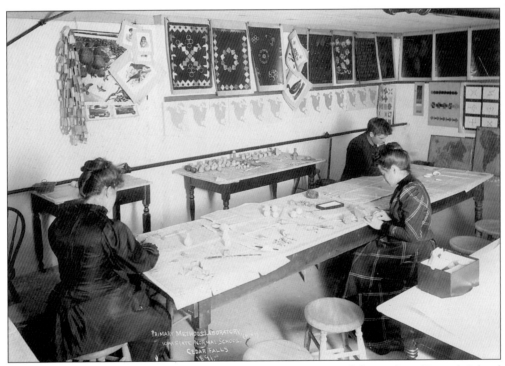

This view of the Primary Methods Laboratory in 1891 is one of the earliest Normal School classroom photos. This classroom, with exposed pipes and a rough ceiling, is probably on the ground floor of Central Hall. In some respects, the displayed work resembles material found in modern Montessori classrooms.

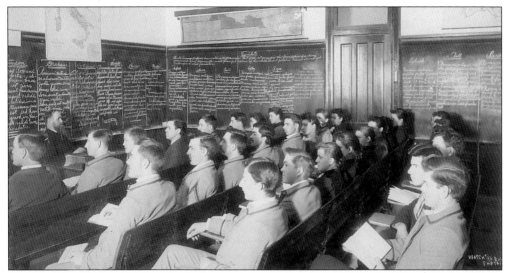

With their signed translations on the boards, students await Professor Loughridge's comments and corrections in this first year Latin class in 1893. Professor Loughridge, a Civil War veteran, provided military instruction in 1890 until Major Dinwiddie arrived; he also taught the first Normal School summer session classes in 1896. Note that most of the young men are wearing cadet uniforms.

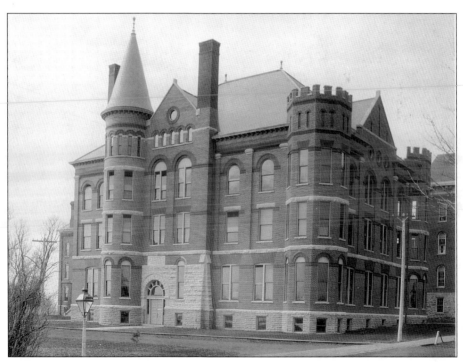

The Administration Building included classrooms, offices, and the library when it was completed in 1895. Its eclectic architectural style made it distinctive even after such features as the conical roof and the soaring chimneys were removed in later years. The building served as the school's administrative center until the new administration building, now called Gilchrist Hall, was completed in 1964. "Old Ad" was razed in 1984.

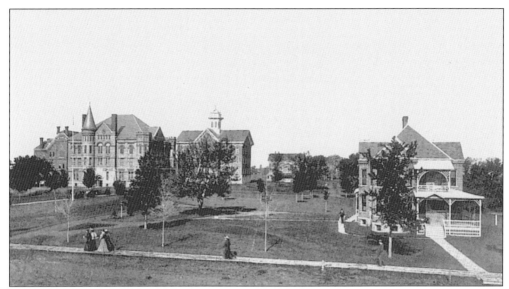

In this picture, students walk to morning classes on the boardwalk next to a very muddy College Street around 1895. In all likelihood, these students walked to campus from Normal Hill rooming houses, or took a horse-drawn hack from more distant accommodations in town. With their long dresses, the women must have been grateful to have the wooden walkway. Of the buildings in this picture, only the President's Cottage on the far right survives.

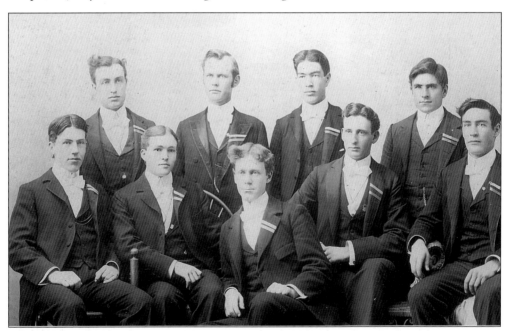

The campus was isolated from town, so students relied on the faculty and each other for enlightenment and entertainment. Literary societies, founded during the school's first year as a means of training future teachers in public speaking, were the most important student organizations. Their meetings and performances, which included music, debate, oratory, recitations, and drama, entertained the whole school. These young men are the 1897 graduates of the Aristotelian Society.

Two

LEADING THE
INSTITUTION

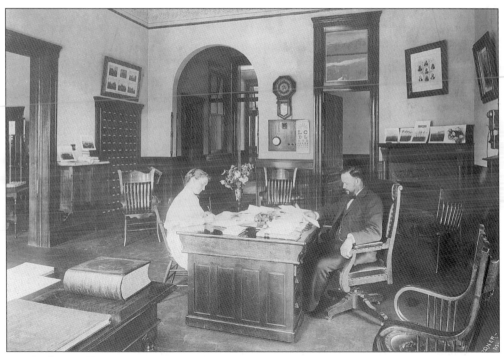

Nearly all school business came across the president's desk during Homer Seerley's administration. His surviving letters fill thousands of pages. In this 1897 photo, he works in his well-equipped new office in the Administration Building with secretary Katherine Schell. Miss Schell later married Charles E. Hearst and became the mother of poet and English faculty member James Hearst.

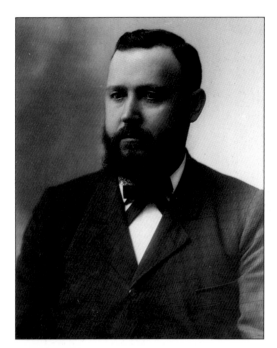

Homer Horatio Seerley, seen here in 1890, had established a strong reputation in Iowa educational circles when the Normal School Board of Directors selected him to replace Principal Gilchrist in 1886. The former Superintendent of Oskaloosa Schools assumed his new duties without fanfare and carefully avoided the potentially divisive factions that arose in the wake of his predecessor's resignation.

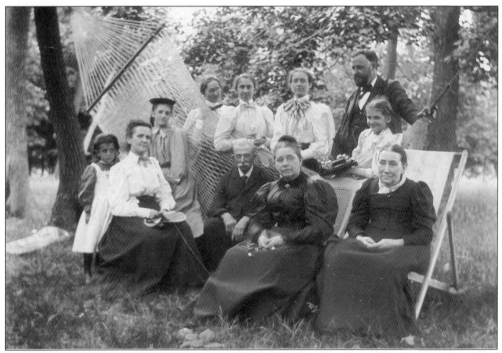

President Seerley, his family, and friends enjoy a picnic in about 1898. In front of the hammock, they are, from the left: daughter Marion Homera, wife Clara, daughter Esther, school engineer Alexander Martz, unidentified, and Mrs. Martz. Standing behind the hammock, they are, from the left: Bertha Patt, Eva Gregg, Emma Ridley, Homer Seerley, and daughter Helen. The death of little Marion in 1899, after a short illness—probably appendicitis—was a sorrow to the family and the whole school.

President Seerley valued his faculty's advice and consulted them often on matters of curriculum, school policy, and student behavior. Here, seated at the desk, he presides over a faculty meeting in the middle 1920s. When this photo was taken, he had appointed nearly everyone in the room.

During the early years of the school's athletic program, President Seerley expressed reservations about the place of athletics in college. To avoid the abuses that made news at other schools, he made sure that athletics remained firmly under the control of the faculty and administration. Here, seated on the right, he enjoys a baseball game in the 1920s. Next to him is L.L. Mendenhall of the men's physical education department.

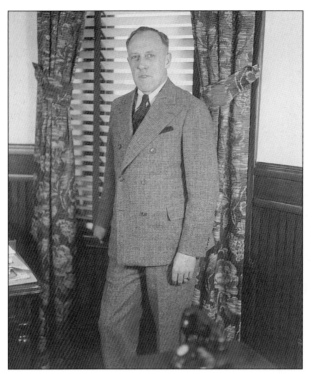

When President Seerley retired in 1928 after a 42-year administration, Orval Ray Latham succeeded him. President Latham energetically tackled problems related to faculty credentials and the college administrative structure. To help solve these problems, he appointed Martin Nelson as Dean of the Faculty, established and re-organized campus offices, and encouraged faculty to pursue additional study.

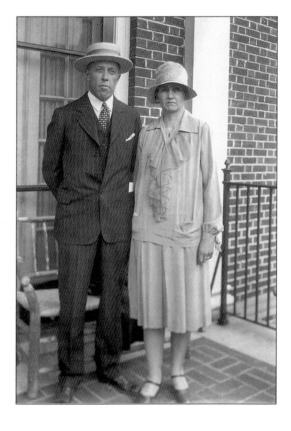

President Latham kept a hectic schedule. On campus he was busy with personnel issues, administrative organization, and building plans, and he also traveled away from campus frequently as a member of accreditation teams. However, in this photo President and Mrs. Latham, standing on the Commons patio, seem to be prepared to enjoy a summer day sometime in the middle 1930s.

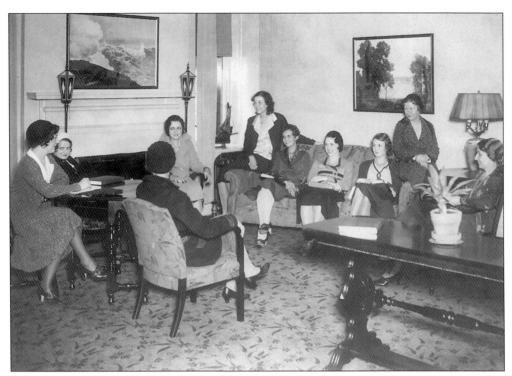

One of President Latham's most successful administrative appointments was Sadie Campbell as Dean of Women, seen here on the far right in a 1932 meeting with students in Bartlett Hall. Miss Campbell had great rapport with students, faculty, and administrators. She was a major influence on the development of the school's residence hall system.

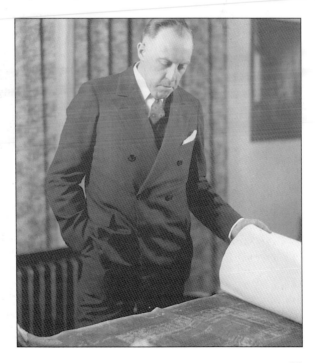

In this photo, President Latham inspects blueprints for a new building. Despite the Depression, he carried out several significant projects. To meet student needs, he developed the first two men's dormitories, the first phase of Lawther Hall, and the Commons. To meet broader campus infrastructure needs, he replaced the inadequate and unsightly power plant in the heart of campus with a modern plant on the south edge.

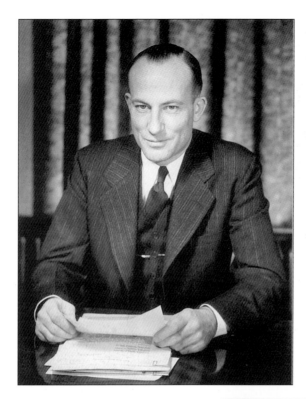

Malcolm Poyer Price became president
after O R. Latham's untimely death
in 1940. President Price took over
a college that was emerging from
the effects of the Depression only to
face the challenges of World War II.
President Price, seen here in 1941,
brought patience and face-to-face,
common sense problem-solving skills
to the job.

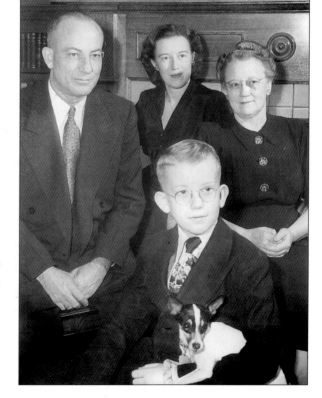

In this photo, taken not long before
1950, the Price family poses in the
President's House; they are, from
the left: Malcolm Price, daughter
Nancy, son John, and wife Mary.
Nancy Price later became a member
of the school's English faculty and
achieved great success as a poet
and novelist.

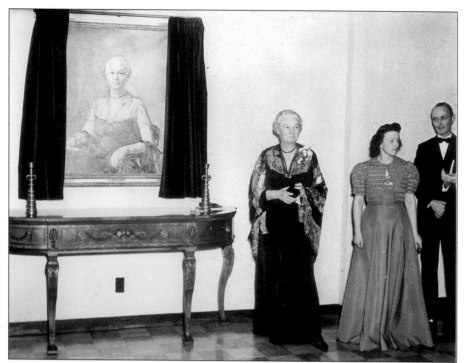

The college named the new women's dormitory for Anna B. Lawther, a member of the school's governing board and a distinguished campaigner for women's suffrage. On January 12, 1942, the school honored Miss Lawther by unveiling her portrait. Herb Hake, on the far right, was master of ceremonies for the occasion, and Emil Bock played violin selections.

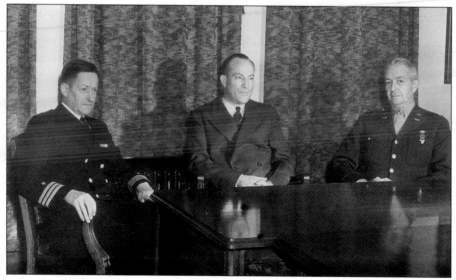

During World War II, the campus was home to training units of the WAVES (Women's Appointed Voluntary Emergency Service) and the Army Air Corps. With declining student enrollment, this arrangement allowed the college to keep its staff employed and its buildings in operation. In this picture, President Price (center) meets with WAVES Commander Everett E. Pettee (left) and Army Air Force Major Julian T. Leonard (right).

25

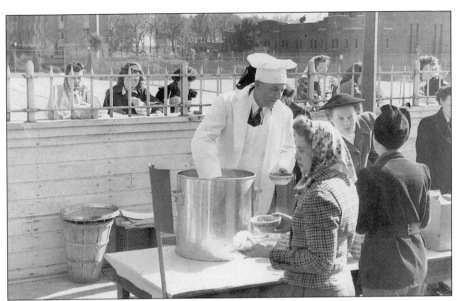

President Price thought it was important to provide traditional college activities for those students who did remain enrolled. He established the Christmas tree-lighting ceremony and utilized convocations during the war years to emphasize the values of tradition and culture. In this shot taken near the old tennis courts, he and home economics instructor Elizabeth Nyholm serve chili on Cut Day in 1943. In exchange for a day without classes, students raked leaves on campus and celebrated with an evening bonfire.

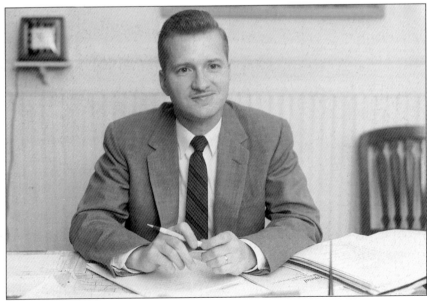

When President Price resigned and returned to teaching in 1950, James William Maucker succeeded him. The college was recovering from the most difficult postwar challenges. Curricular revision, including the addition of graduate degrees, was under consideration. One of the first serious problems that President Maucker faced was a series of charges and countercharges relating to communist sympathies among faculty. The issue was divisive, but after close investigation, it ultimately faded away.

President Maucker, son Jim (top), son Robert (bottom), daughter Ann, and wife Helga pose with the family pets on the stairway in the President's House in the middle 1950s. Redecoration in the early 1950s introduced lighter colors and more contemporary fabrics to the President's House.

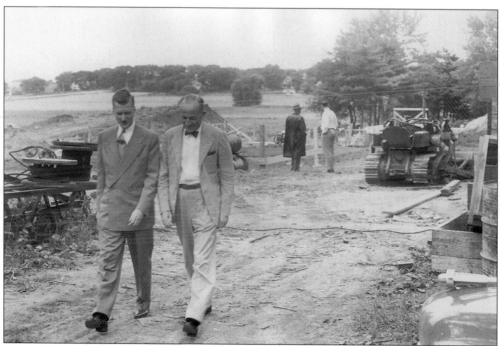

President Maucker (left) and former President Price walk away from the Campbell Hall construction site in 1950. The Campbell Hall project, one of the school's first developments north of 23rd Street, was begun under Price but completed under Maucker. In the background are two other officials with vital interests in campus projects of the 1950s and 1960s—Superintendent of Buildings and Grounds E.E. (King) Cole (in the long coat) and Business Manager Philip Jennings.

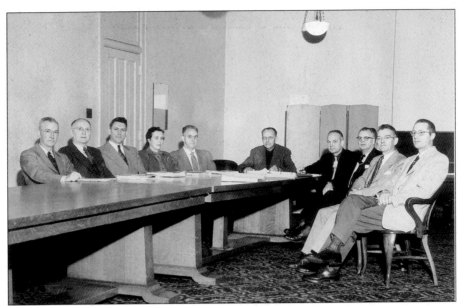

Like his predecessors, President Maucker relied on his administration and faculty for advice and governance. Here the Graduate Council meets in March 1953, shortly after the introduction of graduate study; they are, from the left: C.W. Lantz, M.R. Thompson, Clifford Bishop, Jean Bontz, H.W. Reninger, Martin Nelson, Daryl Pendergraft, Lloyd Douglas, Myron Russell, and Henry Van Engen. Graduate study was a curricular development that had been delayed by World War II and its aftermath.

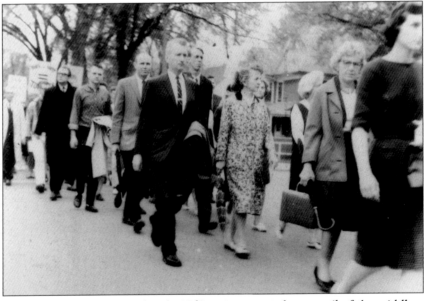

The relatively quiet late 1950s and early 1960s gave way to the turmoil of the middle and late 1960s. On the leading edge of this difficult period, administrators, faculty, and students marched to the Cedar Falls Post Office in the spring of 1964 to mail letters urging passage of the Civil Rights Act. President Maucker and his wife march side-by-side in the center of the shot. Behind them are F.E. (Dee) Smith and Robley Wilson, and on the left, wearing the long, dark coat may be John Eiklor.

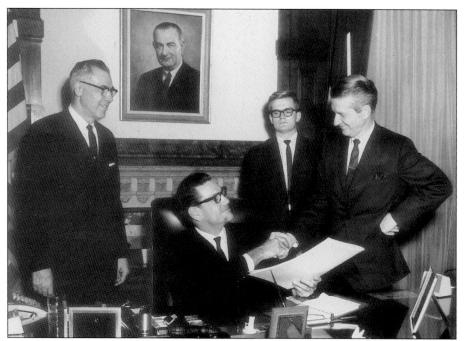

The college changed names twice during the 1960s. In 1961, the Iowa State Teachers College became the State College of Iowa and began to offer non-teaching degrees. Just six years later in 1967, Governor Harold Hughes (seated) signs the bill that changed the school's name to the University of Northern Iowa. Behind him, from the left, are: Dean William Lang, College Eye editor Bob Davis, and President Maucker.

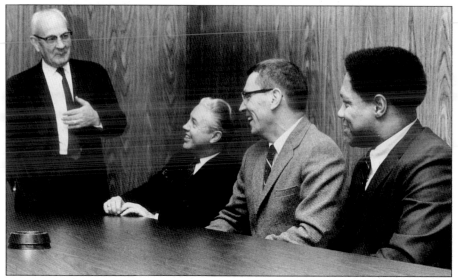

In an attempt to improve race relations, President Maucker established the Committee on University Responsibility for Minority Group Education in 1968. The committee attempted to improve community relations, recruit minority faculty and staff, and increase the number of minority students in the Lab School. Committee Chair Daryl Pendergraft (standing left) addresses Laboratory School Director Ross Nielsen, Professor Tom Ryan, and Director of the Waterloo Human Rights Commission Ronald James.

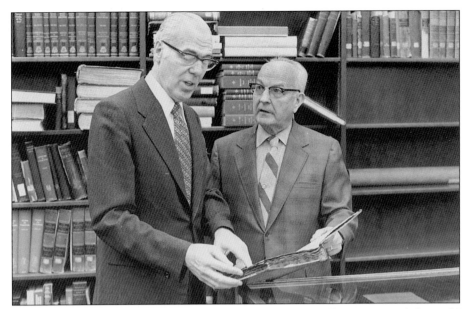

Two of President Maucker's most valuable administrators were William C. Lang (left) and Daryl Pendergraft (right). Each served in a variety of capacities to meet the school's continuing, critical needs. Both men were also dedicated, inspiring teachers. Together they planned to write the school's centennial history, but Professor Pendergraft died suddenly in 1975, leaving only an unrevised manuscript for his portion of the work. Professor Lang ultimately completed the project shortly before his death in 1994.

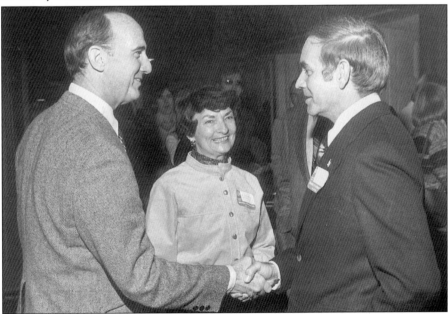

When President Maucker resigned in 1970, John James Kamerick succeeded him. President Kamerick developed and organized the university's administrative structure and was instrumental in the building of the Speech-Art Complex. Another significant effort involved increased outreach to other branches of state government. In this 1976 State Day photo, President Kamerick (left) and his wife Elaine talk with Governor Robert Ray.

Here President Kamerick makes his way through snowdrifts to his office in Gilchrist Hall. Hard winter weather like this, against a background of rising energy prices and tight budgets, made development of the new university structure and curriculum difficult. President Kamerick also had to deal with unresolved issues from the 1960s, including civil rights and faculty governance.

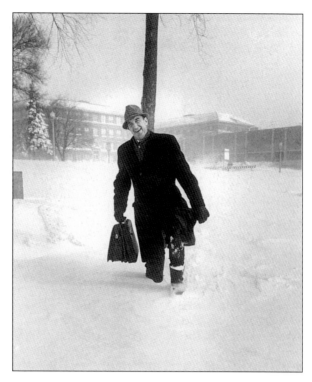

Constantine W. Curris succeeded President Kamerick in 1983. President Curris quickly began efforts to identify and act upon the school's strengths and weaknesses. An area of particular concern was rising enrollment without adequate accompanying state support. The president's strategy in this case was to involve the university in developing a rationale for limiting enrollment.

31

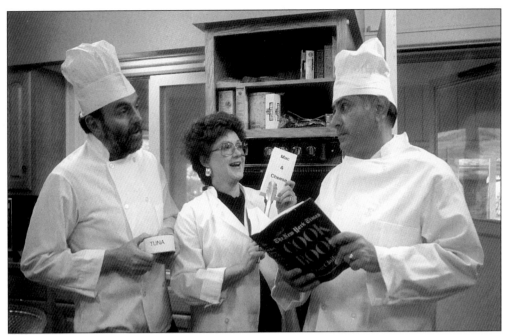

President Curris had a good sense of humor, which, in one instance in 1987, resulted in the delivery of an outhouse to the President's House—courtesy of Des Moines Register writer Chuck Offenburger. In this staged 1992 photo, carillonneur Bob Byrnes (left) and Jo Hern Curris, the president's wife, join President Curris in the kitchen as they prepare a meal for winners of a raffle to raise money for Campanile renovation.

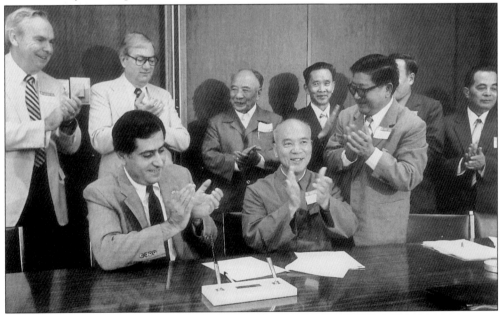

President Curris made extraordinary contributions to the opening of opportunities for study, research, and exchange with universities outside the United States. In this 1984 photo, he signs an agreement with a visiting Chinese delegation. Behind President Curris, are, from the left: Dean of the Graduate College John Downey and Provost James Martin.

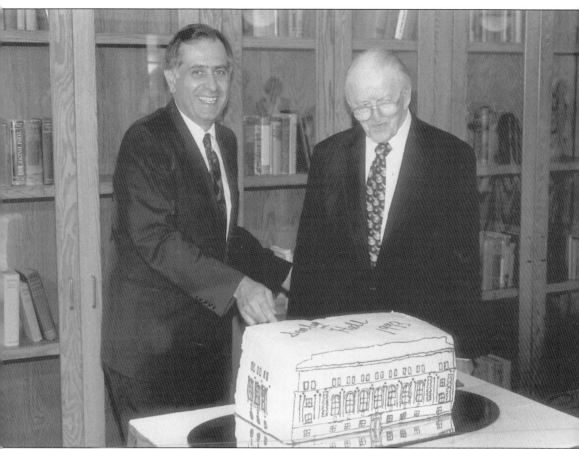

The notable new construction project undertaken during the Curris administration was the Business Building, completed in 1990. But at least as remarkable was the renovation of Seerley Hall, which restored the former library and classroom building to its original, early twentieth century grandeur. Here, at the Seerley Hall rededication in 1993, President Curris cuts a cake shaped like Seerley Hall with Homer Culley, a grandson of President Seerley. Mr. Culley was born in the President's House on June 1, 1915.

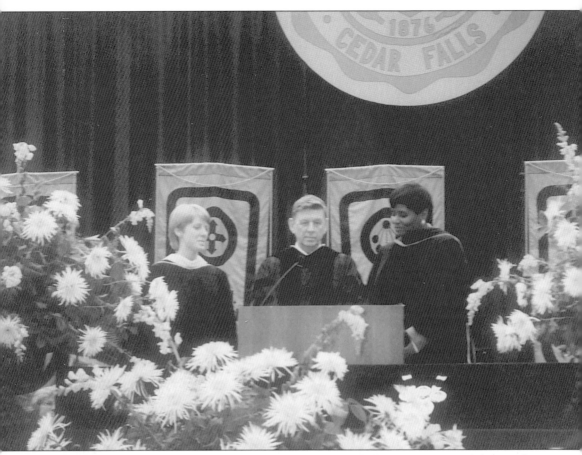

When President Curris resigned in 1995, Robert D. Koob became UNI's eighth president. President Koob, a 1962 alumnus of the college, began a process of decentralizing portions of the budget and also sought ways to assure that UNI students and faculty had access to the latest educational technology. Regents Aileen Mahood (left) and Beverly Smith (right) assist at President Koob's Investiture in 1996.

Three

TEACHING AND LEARNING INSIDE THE CLASSROOM

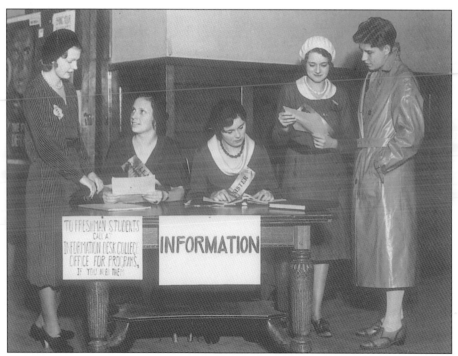

On September 6, 1876, the school's first day of instruction, registration was complete when Professor Bartlett had entered each student's name in a ledger. With just 27 students present, the process went quickly. Over the years registration became more complicated, but the poised students at the registration information desk in this 1932 photo seem relaxed. The young man, in his plus fours and oilskin slicker, is a fashion plate for his day.

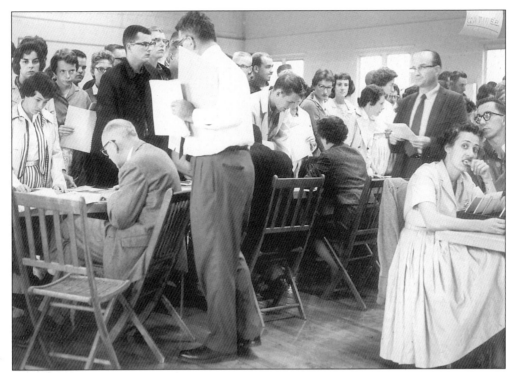

No, this is not a poster for twentieth century angst; it is registration in the middle 1960s. With enrollment soaring, registration became an exhausting and frustrating affair of over-booked classes and searches for appropriate signatures. Long lines of waiting students stretched outside registration sites. Many registration problems persisted until computers began to offer a good range of solutions in the 1990s.

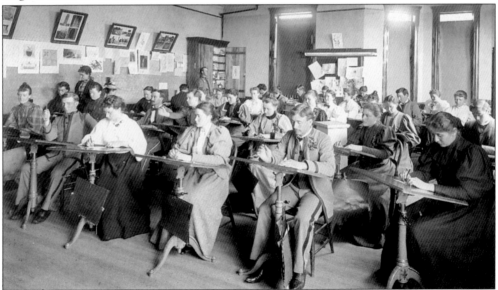

These students seem to be seriously engaged in their work in Professor Henrietta Thornton's drawing class in 1897. The adjustable worktables must have been a welcome and rather special feature for the school at this date.

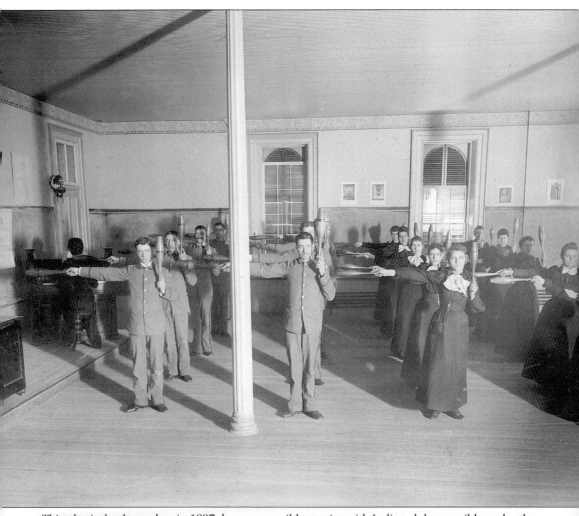

This physical culture class in 1897 does some mild exercise with Indian clubs, possibly under the direction of Laura Falkler. One can only hope that they spread out a bit before they really began swinging the clubs. The player at the keyboard in the left background may have been providing some kind of accompaniment to the exercises. Note that kerosene lamps light the room, which is probably in Central Hall.

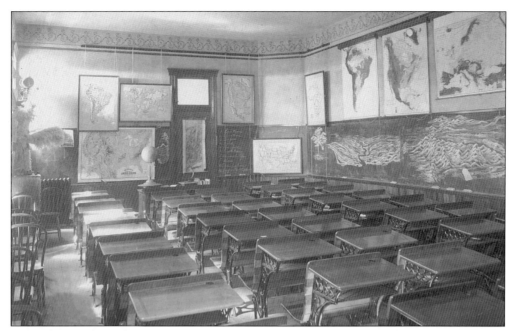

This is the physiography classroom in 1903, where students learned physical geography. Despite the abundance of maps in the room, the importance of class boardwork is apparent. The school wanted its students to enter the teaching profession with a sound background in this pedagogical technique.

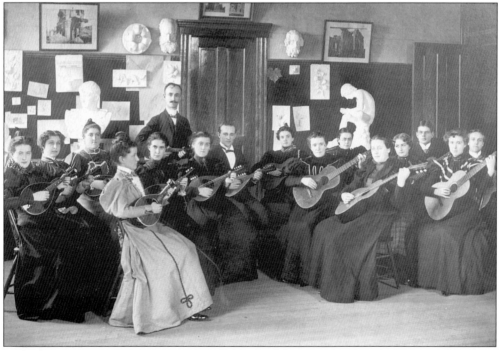

Professor Fitzgerald, pictured here with a mandolin and guitar group in about 1900, was an accomplished musician, instructor, and conductor. Under his inspiring leadership, student participation in music increased substantially in both quantity and quality.

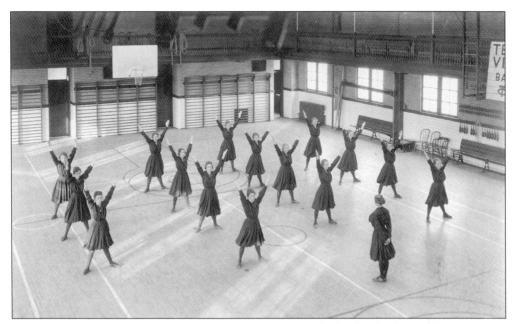

As interest in physical education spread through grade and high schools, demand for instructors reached the teachers colleges. Consequently, despite the initial negative reaction of some faculty, physical education became part of the college curriculum. The pace of the activities was certainly gentle compared with modern aerobics and marathon classes. Here a group of women exercises in the East Gym in about 1915.

Pictured here in 1935 are Monica Wild (left) and Doris White (right) of the women's physical education department. Their textbook on physical education for elementary schools went through at least a dozen revisions over more than 40 years. So well-known was their work that "Wild and White" became eponymous for the physical education curriculum in the schools of Iowa and beyond.

Frank Ivan Merchant earned his Ph.D. at the University of Berlin and taught classical languages at the college for over 30 years. The Merchant family built and lived in the house at 1927 College Street, now occupied by Delta Upsilon. Under terms of his will, Professor Merchant and his sister Kate Matilda donated more than $100,000 to establish a scholarship to support UNI alumni in their graduate study. Well over 100 UNI alumni have received Merchant Scholarships since the first award in 1954.

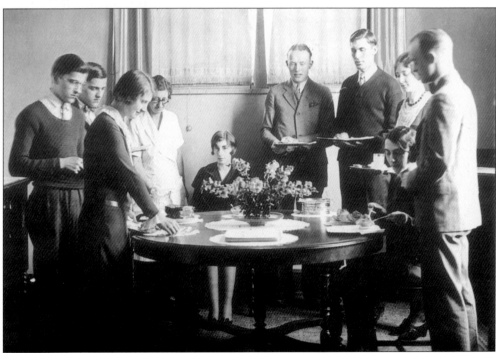

Home economics was one of the expanding vocational education curricula in the 1930s. With both practical and pedagogical intent, the program taught students how to take care of children, prepare food, make and maintain clothing, and decorate a home. Students in this 1930 photo are about to enjoy the results of a meal-planning unit. The hostess is demonstrating how to serve a meal in this particular style.

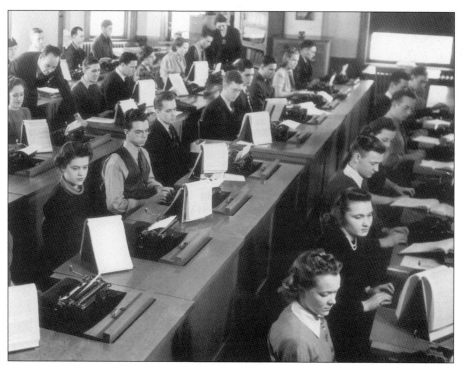

The business education curriculum developed under the guidance of Lloyd V. Douglas, a nationally recognized leader in his field. Here a class works on typing skills in a well-equipped classroom around 1940.

Under the gaze of Wendell Willkie, M.R. Thompson, head of the Social Science Department, makes a point to his students in 1944. The Social Science Department, with faculty such as Leland Sage, Erma Plaehn, Don Howard, and William Lang, developed a particular strength in contemporary affairs that blossomed into study trips abroad and the All-College Conference on International Affairs.

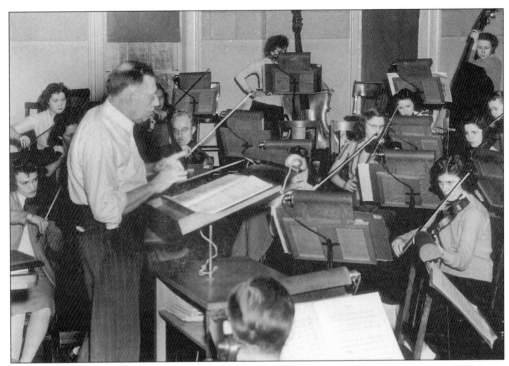

Edward Kurtz headed the Department of Music from 1924 until his retirement in 1951. He composed original orchestral work and also contributed to the literature of methods. Here, with his sleeves rolled up, he works with a string group in 1944.

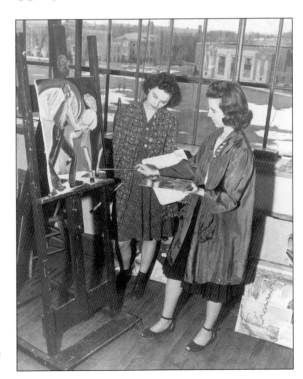

Two students use the natural north light of Wright Hall studios to work on their painting skills in 1946. Note the swimming pool building (right) and the Commons (left) through the windows.

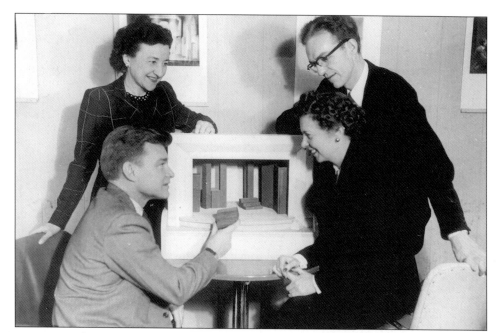

Participants and spectators have enjoyed dramatic productions on campus since at least 1878. This talented quartet of teachers, examining a stage model in 1949, was responsible for directing much of the school's finest drama for over 60 years; they are, clockwise from the lower left: Stanley Wood, Hazel Strayer, Richard Bergstrom, and Elaine McDavitt.

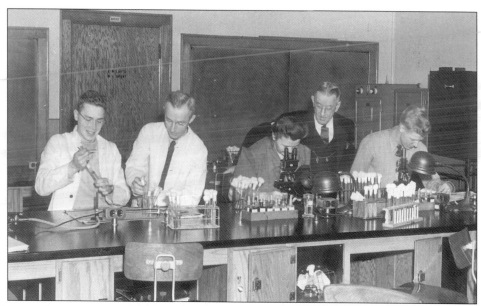

Here professors assist students in some lab work in 1944; they are, from the left: unidentified, C.W. Lantz, Marvel Jones, E.J. Cable, and Richard Van Dyke. During his long career, Professor Lantz was active in professional and civic affairs. He was instrumental in the development of the university's Biological Preserves System. Professor Cable served the school as a teacher, administrator, and museum curator for 58 years. He served on important faculty committees and was a respected author of science texts.

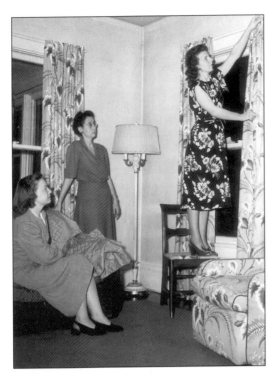

After World War II, the college expanded its efforts into adult education classes to meet the needs and wishes of students, their families, and local residents. Pictured here in 1948, an unidentified student teacher (left) and home economics instructor Lela Mae Ping (center) observe Mrs. Ray Nelson as she hangs curtains to match the upholstered chair.

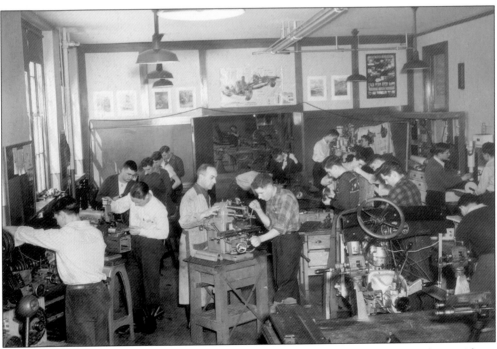

Harold Palmer (a little left of center and wearing a lab coat) is seen here working with an auto shop class in 1954. Professor Palmer was a leader in the field of industrial arts education. He used his positions in local, state, and national associations to promote professionalism in teacher education.

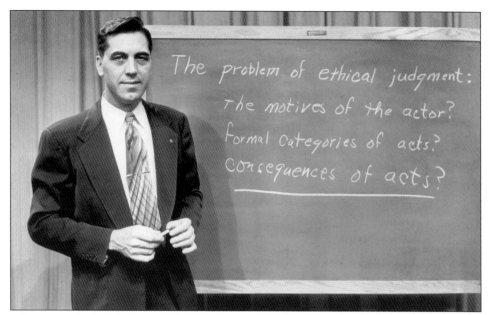

The problem of ethical judgment:
The motives of the actor?
Formal Categories of acts?
Consequences of acts?

Josef Fox was the best-known teacher at UNI in the 1960s and early 1970s. Many students took his humanities classes, and the rest knew him from his controversial column, Obiter Scripta, in the student newspaper. Some loved his pronouncements, and others thought they went too far, but no matter what one thought of him, Professor Fox was a force to be reckoned with on campus. Here he teaches a humanities course via television.

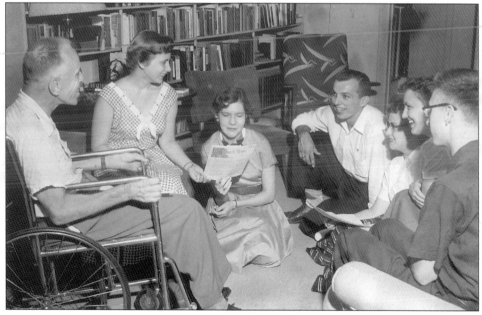

James Hearst, one of Iowa's finest poets, developed his poetic skills while farming southwest of the college. In 1941, H.W. Reninger, head of the English Department, asked him to join the faculty. This began a wonderfully productive relationship for Professor Hearst and generations of students. Here Professor Hearst (left) conducts a class in his home, which later became the Hearst Center for the Arts.

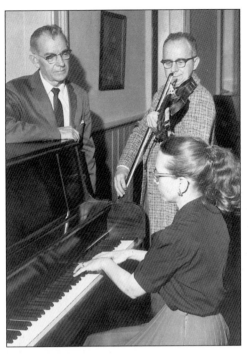

The Department of Music maintained a strong reputation for the performing and teaching talent of its faculty. In 1961, W.W. Clover presented a violin and a piano to the school in memory of his wife, alumna Ethel Horn Clover. Here, Myron Russell, head of the department, listens to Professor Emil Bock play the violin and Professor Jvone Maxwell play the piano.

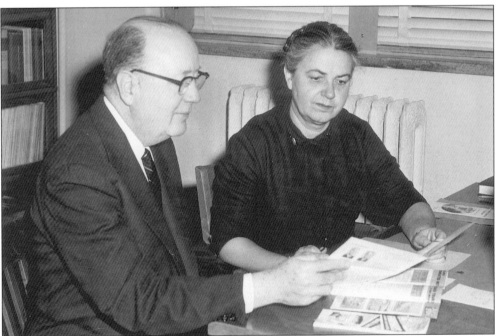

Leland Sage and Erma Plaehn consult here in 1957, possibly about a Social Science Seminar trip abroad. Professor Sage, one of the most respected members of the faculty, taught history for over 50 years. He wrote two standard works on Iowa history and chaired the Lecture-Concert Series for many years. Professor Plaehn was a scholar who was active in the community and in professional associations. Her students appreciated her teaching ability and her personal interest in their welfare.

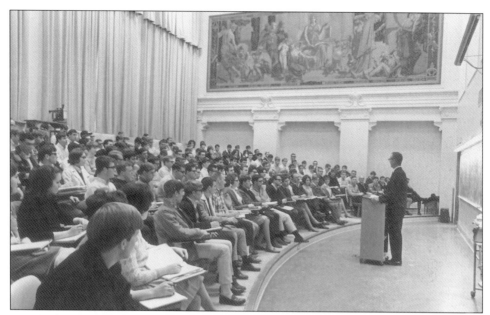

Leonard Keefe was a pioneer in developing the business curriculum from its business education foundations. Professor Keefe, an excellent marketing teacher, also had the respect of his faculty peers—he served long terms on influential faculty committees and as Faculty Senate chair. Here he teaches a class in one of the large lecture rooms created from the former library reading room in Seerley Hall.

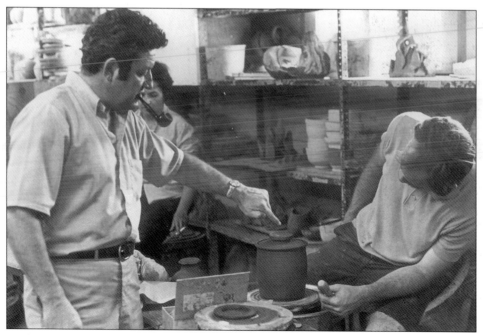

Many fine artists, working in a wide variety of media, have taught at the school. Here Don Finegan instructs a student in a particular technique in the ceramics studio in 1969. Professor Finegan taught at UNI for over 30 years and created artwork for many sites in the local community, including "Symphony in Three Forms," the sculpture in front of Russell Hall.

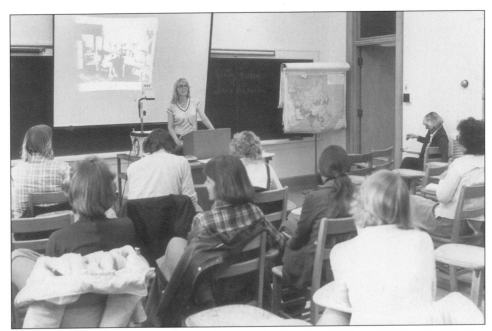

New disciplines of study emerged from the turmoil of the late 1960s and 1970s. At UNI, Grace Ann Hovet in English and Glenda Riley in history pioneered the Women's Studies Program. Here, with the iconic names of Betty Friedan and Simone de Beauvoir on the board, Professor Riley teaches a class in women's studies in 1978.

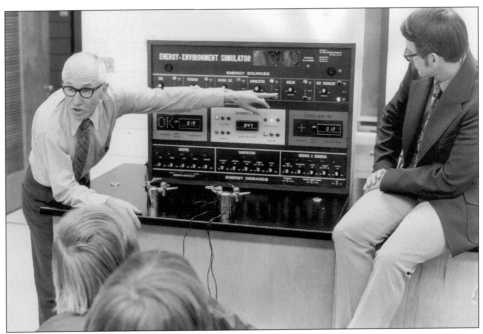

Local citizens frequently take classes or participate in special programs on campus. In this photo, Leland Wilson, head of the Chemistry Department, uses a simulator to demonstrate to a citizens' workshop the difficulties involved in the generation and use of electrical energy. Paul Rider, also of the Chemistry Department, observes on the right.

The school has long taken pride in giving students access to senior faculty both as classroom teachers and as advisors. Here Darrell Davis goes over a problem with a student in 1982. Professor Davis has been a distinguished accounting teacher, administrator, and faculty leader over his long career.

Since at least the early 1970s, accounting has been one of the school's strongest programs. On a national level, UNI students consistently pass the CPA examination and achieve other distinction at very high rates. Professor Gaylon Halverson, who led the accounting program for many years, must just have said something funny in this 1986 class. Who says that accountants lack a sense of humor?

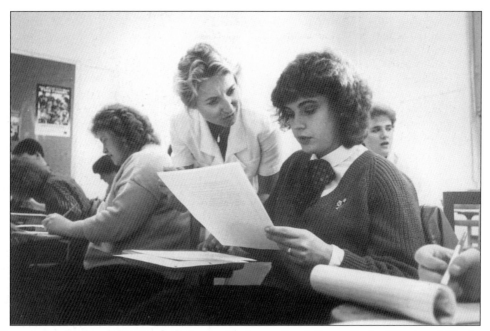

Fine teachers such as Selina Terry, Katherine Buxbaum, Brock Fagan, Evelyn Wood, and Charlene Eblen have been part of a tradition that aimed for all students to write competently. In addition, student publications such as Purple Pen, Seven, and Inner Weather provided opportunities for talented writers, such as future Poet Laureate Mona Van Duyn, to display their skills. In this photo, Barbara Lounsberry assists a journalism student in 1986.

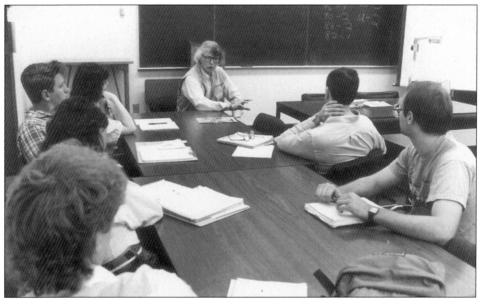

Alumnus Robert James Waller returned to his alma mater to teach business, conduct research on decision making, and serve as Dean of the College of Business Administration. After he stepped down as dean, he wrote on topics relating to Iowa's economic and social future. He later achieved an international reputation as the author of The Bridges of Madison County. Here Professor Waller instructs a management class in 1988.

Science education has been a strong and popular curriculum at UNI for many years. Since the 1960s, it has consistently attracted major grants to its innovative programs, especially in the area of in-service development for science teachers. In this 1988 photo, Professor Verner Jensen demonstrates physical principles to interested students.

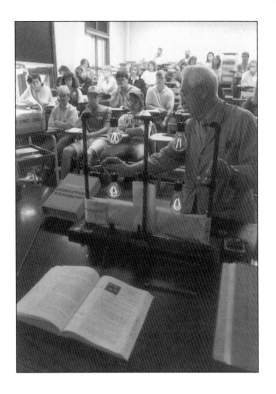

John Eiklor was a much-beloved and inspiring teacher of history and humanities at UNI. He traveled widely and collected books with a passion. Here Professor Eiklor chats with students after class in 1991.

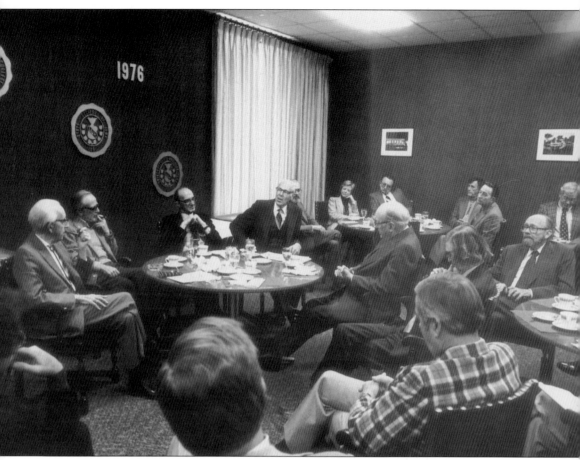

This 1981 meeting to honor those involved in the humanities program probably brought together more teaching talent than has ever been assembled in one room on the UNI campus. At the head table, they are, from left to right: H.W. Reninger, Ken Lash, John Kamerick, William Lang, and Leland Sage; (back left table) Howard Thompson, Loree Rackstraw, John Eiklor, Alvin Sunseri, and Thomas Thompson; (back right table) Tom Ryan; (middle right table) James Martin (checked jacket), John Cowley, and George Poage.

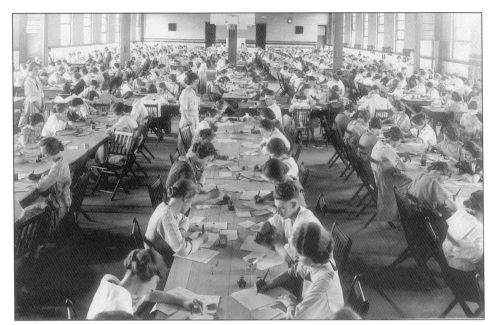

Most classes end with some kind of examination. Students have fretted and complained about the whole exam process since the earliest days of the school. These students are writing the examination for teaching certification in June 1921. This is an especially good look at the hairstyles and informal summer clothing of that day. Within a short time, bobbed hair and new clothing styles would change students' appearances radically.

Those who successfully completed their classes and examinations then finished their college careers with the Commencement ceremony. These ceremonies traditionally included a procession, music, speeches, and the presentation of degrees. In this photo, which was taken around 1928, relatives and friends have parked west of the Campanile and are walking to the ceremony, probably in the auditorium.

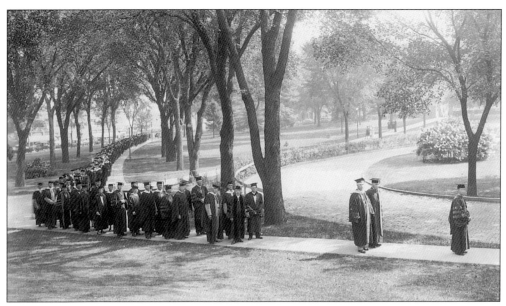

Commencement sites over the years have included the east lawn, Gilchrist Chapel, the Auditorium, West Gym, O.R. Latham Stadium, and the UNI-Dome. This early 1930s Commencement procession, led by the faculty in regalia, has lined up in the shade of the elms on the sidewalk curving toward 23rd and College Streets. President Latham is second from the right.

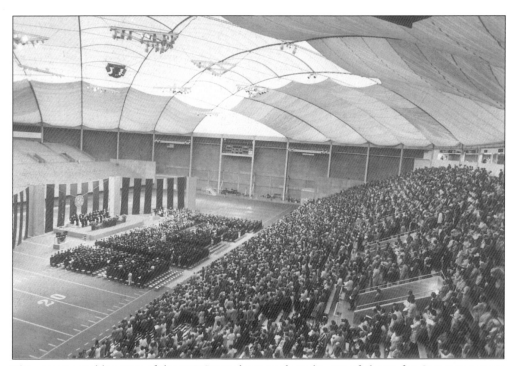

The capacity and location of the UNI-Dome have made it the site of choice for Commencement in recent years. Pictured here is the first Commencement held in the Dome in 1976.

Four

TEACHING AND LEARNING
OUTSIDE THE CLASSROOM

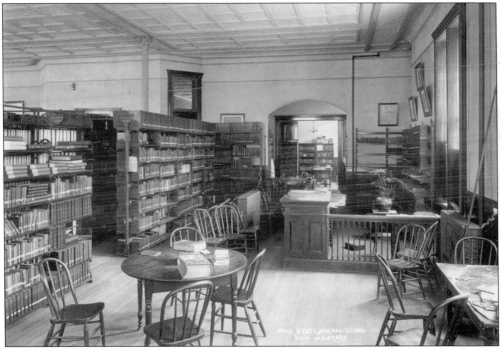

When the school opened in 1876, it had no appreciable library. Principal Gilchrist graciously made his private library available to students during his administration. President Seerley repeatedly requested funds for both floor space and collections. The Administration Building, completed in 1896, provided the school's first space purposely designed as a library. This 1903 view shows a relatively large classified collection, a service desk, and study space.

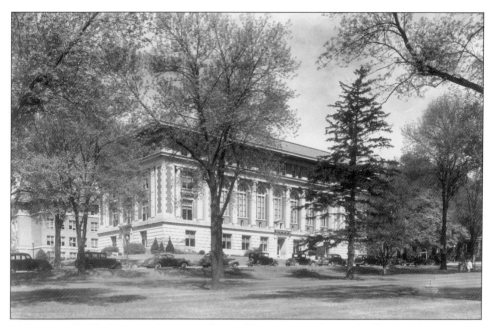

President Seerley had a grand vision of a building designed specifically for library services, staffed by professional librarians, and accommodating a collection of 100,000 volumes. This was forward thinking for the president of a young Midwest normal school. But with the completion of the classically-styled building now called Seerley Hall in 1911, the vision was realized. The building, shown here in about 1940, housed the library and the museum for over 50 years.

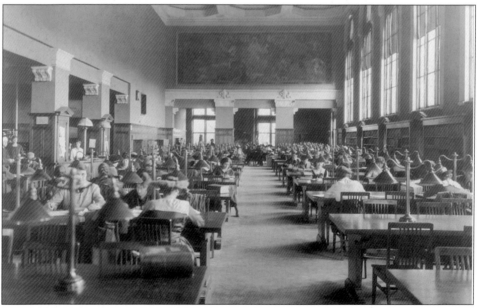

The center of the library was the reading room where students checked out books, conducted research, studied, and met friends. Artwork adorned the library walls so that students would have a further opportunity to enhance their education. This photo is from 1920 or 1921, after artist William de Leftwich Dodge had installed the north and south murals, but before he installed the larger west panel. These allegorical panels, restored in 1995, trace the history of Western culture.

The new library was built in three construction phases ending in 1964, 1975, and 1995. Library Director Donald O. Rod used his expertise in both architecture and library management to assure that the building could be modified easily to accommodate changing needs. This 1965 shot looks over the park-like circle that President Latham had landscaped in the 1930s. Maucker Union now occupies this site.

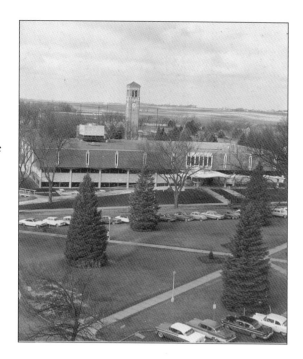

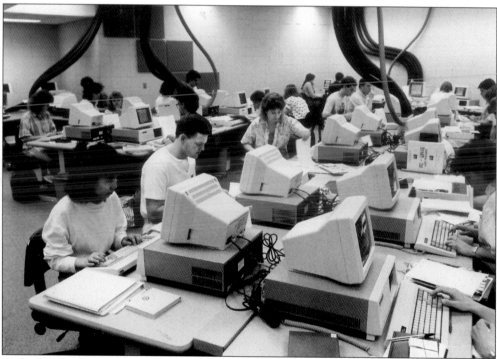

Early campus computing was largely confined to the business office and to curricula with technical requirements. But by the 1990s, students and faculty in just about every curriculum needed access to computing resources and the Internet in order to conduct their work. Computer centers, with long hours of service, were established in several locations. These students are working in a computer center in the library in 1989.

Through the efforts of men like J.O. Perrine and Eugene Grossman, the campus had some early exposure to radio. Here over a thousand students gather in March 1925 to hear President Coolidge's inaugural address being broadcast from a radio receiver installed by student Bob Cummins in the Physics Building, on the far right. Classes were dismissed for the event.

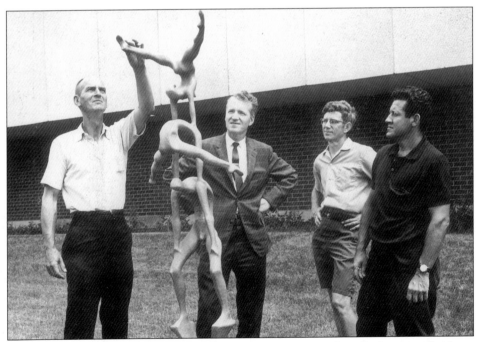

Since the time of President Seerley, building hallways have served as display areas for fine art. In the 1960s, the art collection expanded outdoors as well. Here, from the left, sculptor Edward Whiting, President Maucker, and art professors John Page and Don Finegan inspect a model of Whiting's "The Acrobats." Students liked the full-scale sculpture when it was installed near Redeker Center, though it has occasionally been decorated with assorted underwear.

58

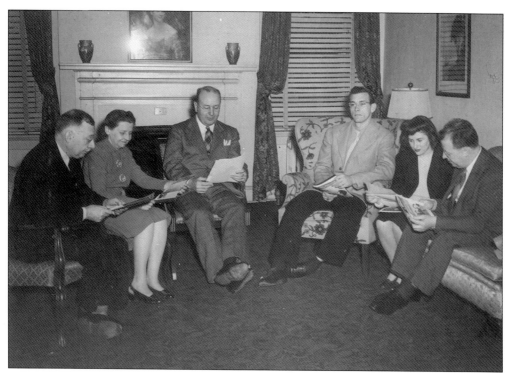

Some of the most famous and talented speakers and performers in the world have appeared on campus in lecture and concert programs stretching back at least to 1915. Committees under the skillful leadership of Leland Sage, Herb Hake, and Howard Jones developed outstanding annual series. Here, in 1947, the committee checks its selections for the year; they are, from the left: Edward Kurtz, Sadie Campbell, Leland Sage, Eugene Bielke, Mary Wombolt, and Vernon Bodein.

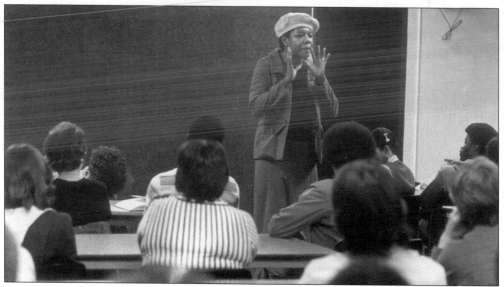

In recent years, the university has been able to bring performers and artists into classroom situations for closer contact and informal discussion with students. Here Maya Angelou talks with a group of students in 1978.

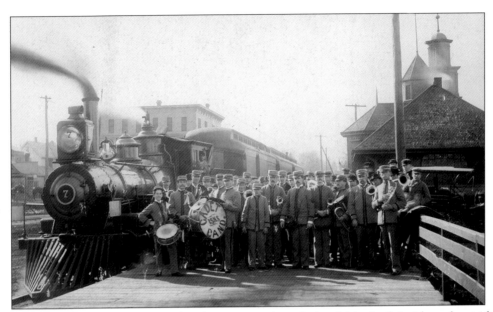

Students have participated in vocal and instrumental musical activities both inside and outside the classroom since the earliest days of the school. Almost all early public entertainment included some kind of musical presentation. Here the Cadet Band, consisting of men in the student military battalion, assembles at the Burlington, Cedar Falls and Northern Railroad to accompany the oratorical team to Cedar Rapids in 1896.

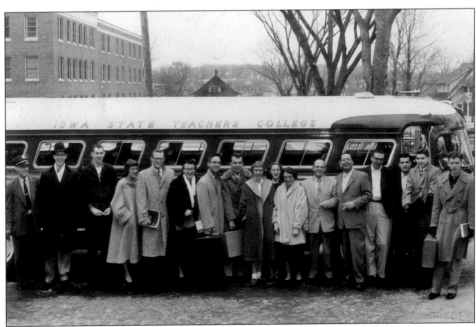

Sixty years later, the debate team is off on another trip—this time they are assembling near Campbell Hall for a trip to Wisconsin in 1955. From left to right they are: driver Clarence Lauver, H.M. Hougen, Bob Cleveland, Yvonne Cleveland, Victor Diercksen, Professor Lillian Wagner, Johnny Jones, Niel Ver Hoef, Esther Kling, Kay Winter, Shirley Whannel, Professor M.B. Smith, Richard Flowers, Dean Funk, Dean Frantz, Roger Farley, and Leo Munday.

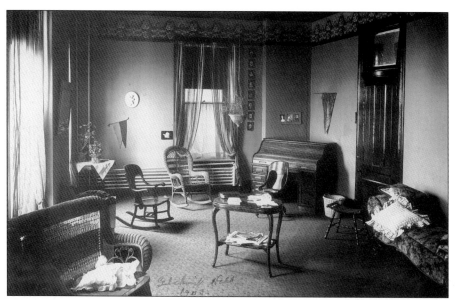

Many students brought their own religious faiths to campus where they joined other students of the same faith or formed nondenominational or interdenominational groups. The YMCA and YWCA were inclusive Christian groups that were influential and extremely popular in the school's early years. The strength of their programs attracted national attention. Pictured here is the comfortable-looking YWCA room in Old Gilchrist Hall in 1903.

Because of the school's distance from Cedar Falls churches, nondenominational worship services were held regularly on campus. This led to the founding of the College Hill Interdenominational Church in 1926, whose congregation consisted primarily of faculty, students, and other College Hill residents. The clergyman, who taught college classes and served as pastor of the church, received compensation from both the college and the church. This is a 1929 communion service in the auditorium, the home of the church.

Literary societies were meant to provide opportunities for future teachers to hone their public speaking skills, but they also became the most important and influential social groups on campus. They organized entertainment, fielded athletic teams, and edited the student newspaper. Here the Orio Society presents a dramatic selection in 1897; they are, from the left: Alice Fullerton, Maude Foote, Guy Green, Harold Nye, Alice Peters, Jay C. Huntley, and Clifford S. Beall. (Courtesy Lewis A. Warwick.)

Among other activities, literary societies participated in the May Day celebrations. This is the Homerian Society's entry in the May Day parade as it pauses at the corner of Sixth and Main Streets in front of the Cedar Falls Public Library. The societies fell out of fashion in the early 1930s. Other campus groups gradually absorbed their useful functions.

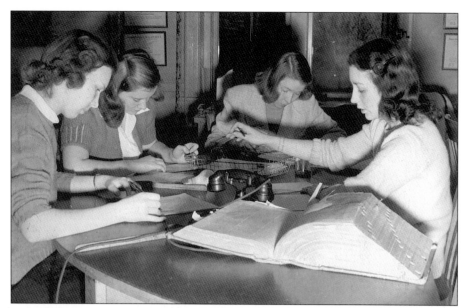

Student publications have informed and entertained the campus since 1878. Despite complaints about their style, quality, and coverage, the newspapers, yearbooks, and literary magazines provide an excellent students' eye view of campus life. These four College Eye staffers appear to be working late against a tight deadline.

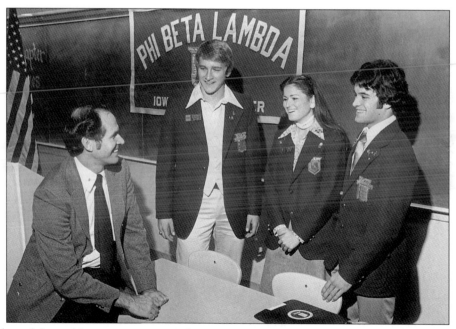

Student clubs and interest groups are almost too numerous to count. Students have organized to play chess, speak German, compete in College Bowl, watch films, run marathons, take photos, talk with international students, read poetry, clean up litter, and a hundred other activities. Professional interest groups, organized for just about every curriculum, combine social and career-oriented activities. These students from UNI's Alpha chapter of Phi Beta Lambda are talking with advisor Gordon Timpany in 1977.

Students have participated in all sorts of choral groups. In this photo, six glee clubs—the Cecelians, Bel Cantos, Euterpeans, Aeolians, Minnesingers, and Troubadours—combine into a choir of 300 voices for the traditional performance of Handel's "Messiah" in 1930. Professor Charles Fullerton directs and George Samson, Jr., is at the organ.

The college marching band performs a routine in 1929 on a playing field now occupied by the Rod Library. Distinguished directors such as Myron Russell, Karl Holvik, and William Shepherd have made the band a welcome performer in parades, at athletic events, and in concert for 80 years.

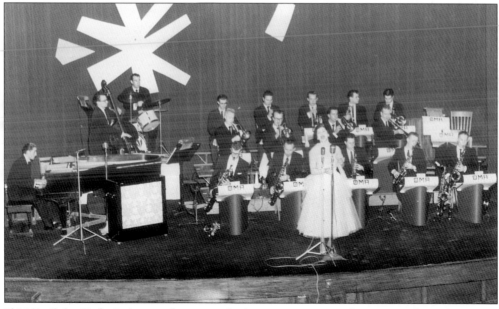

Phi Mu Alpha Sinfonia jazz performances had to overcome initial resistance from those with conservative musical tastes, but by the middle 1950s, their performances were a hit with students and an eagerly-awaited activity on the college calendar. Since then, the Jazz Band has performed with major jazz artists and earned wide recognition for excellence. In this 1955 photo, Betty Olinger sings with the band.

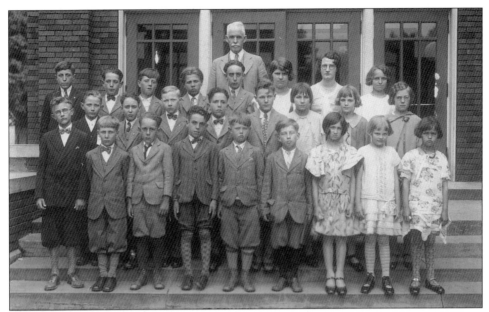

Charles A. Fullerton believed in bringing vocal music to Iowa's children. He developed a program that placed phonograph recordings of selected songs in rural schools where the children practiced singing along with the music. Then they came together to sing in mass choirs. Here Professor Fullerton stands with a group of school children from the St. Donatus Rural School Chorus in 1930.

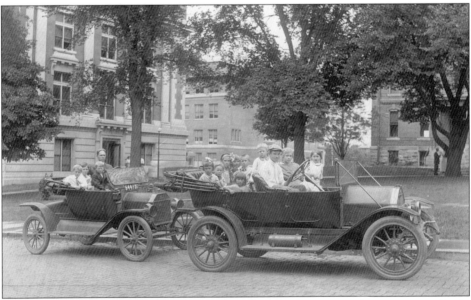

Since 1913, the school has provided its expertise to the state, and especially to rural school districts, by means of the Extension Division. Automobiles improved the delivery of these services. Extension Director Irving Hart (the driver of the car on the left) was among the first faculty to own a car. Roderick Fullerton is at the wheel of the car on the right. The children are part of a teaching demonstration project in the summer of 1915. In the background is the north side of Seerley Hall.

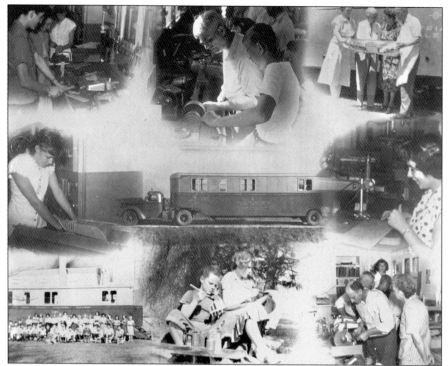

This composite photo illustrates a special project inaugurated in 1948 in which the Extension Division and the industrial arts faculty equipped a trailer with machine shop tools. The trailer, with its own generator to run the equipment, visited rural and small school districts so that students and teachers could use machinery that their schools could not afford. Industrial Arts Department head Harold Palmer hoped that the demonstration would inspire smaller districts to improve the quality of their instructional programs.

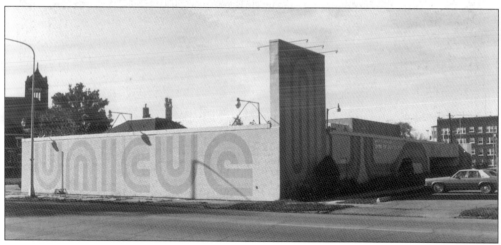

To demonstrate the university's interest in minority group education, President Maucker established the first UNI-CUE (Center for Urban Education) in an old house on Vine Street in Waterloo in 1969. The program later moved to much larger quarters in the former grocery store on East Fourth Street pictured here. Over the years the university has provided a variety of programs, including coursework, tutoring, and academic counseling at UNI-CUE.

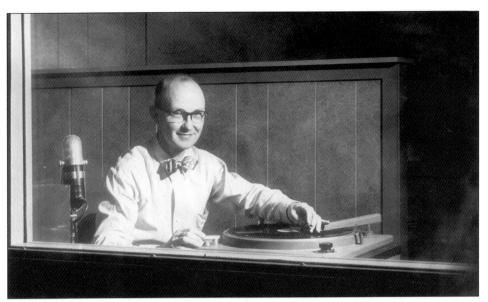

When English Department head H.W. Reninger asked Herbert Hake if he had experience in radio, Mr. Hake said, "Yes." Mr. Hake recalled later that he did not think it wise to explain that his radio experience was limited to playing a banjo. With that hallway conversation, Mr. Hake began a 30-year career of directing broadcast services for the college. Mr. Hake, shown here in about 1950, may be best known for his Landmarks in Iowa History television series.

The college began its instructional and entertainment broadcasts on KXEL in 1942 under the direction of Herb Hake. These broadcasts showcased faculty talent in panel discussions, radio classrooms, and musical presentations. George Samson, Jr., on the organ was a musical favorite, as was the College Quartet composed of (from the left and standing): Jane Birkhead, Jane Mauck, Maurice Gerow, and Harald Holst, with Elaine Jacobsen at the piano.

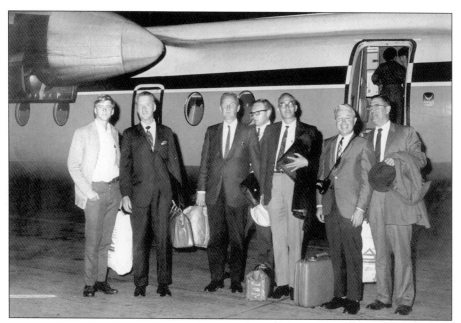

The college attempted to enrich students' education by opening international exchange opportunities. One major attempt involved a "sister school" relationship with the Universidad Pedagogica Nacional in Colombia. Here UNI representatives return home after a trip to Bogota; they are, from the left: Robert Maucker, President Maucker, Wallace Anderson, Richard Brook, Don Hawley, Ross Nielsen, and Ray Schlicher.

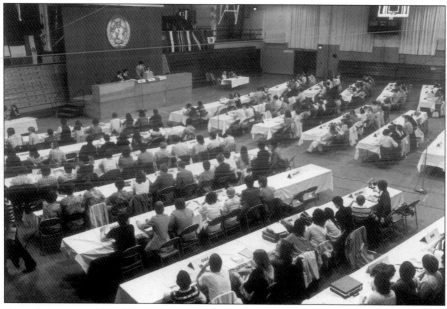

The All-College Conference on International Affairs and the Model United Nations, shown here, brought additional international influences to campus. George Poage organized the first Iowa High School Model UN in 1966. These workshops, supervised by college students, brought hundreds of high school students to campus to play the roles of representatives from countries around the world.

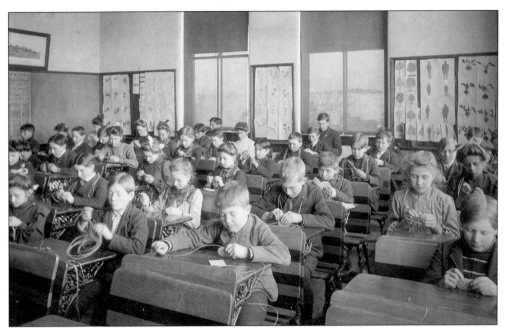

As early as 1883, the Normal School offered a model school where student teachers could observe, learn, and participate in advanced teaching techniques. Student teaching became an important part of prospective teachers' training. Local children benefited from attending a "laboratory" school. Here sixth graders in the model school in 1893 work on basket projects.

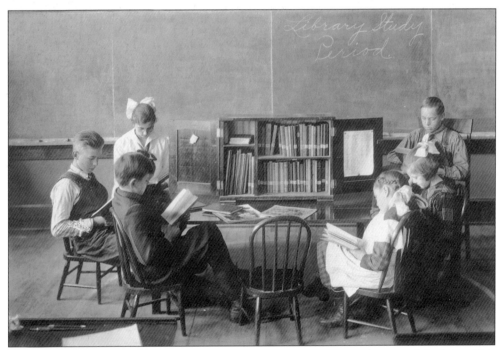

The campus school attempted to be a model in management, teaching, and facilities. This classroom library, neatly packed into a cabinet, was probably a good example of well-managed resources for its day. The chairs and tables, however, do look small for most of these children.

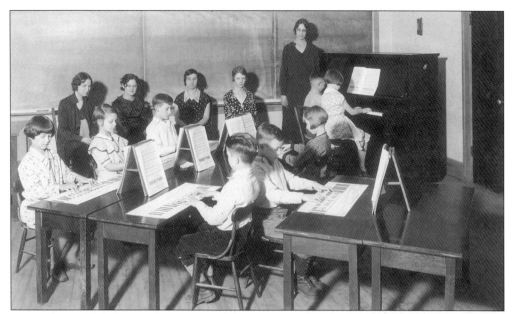

These student teachers from a piano methods course observe teacher Naomi Evans conducting a class in the campus school around 1930.

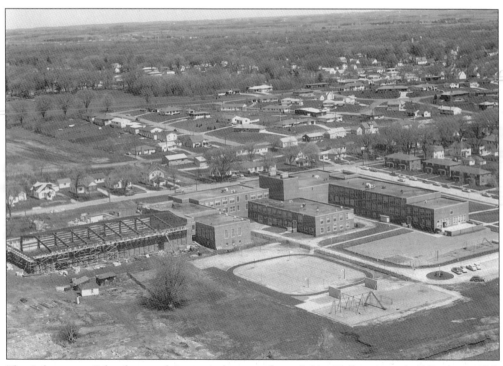

The Laboratory School moved in several stages from Sabin Hall to new buildings on 19th Street in the middle 1950s. This aerial view taken in 1957 shows the first fieldhouse still under construction. Named for former president Malcolm Price, this school provided a research venue for new teaching techniques and convenient student teaching opportunities for countless UNI students.

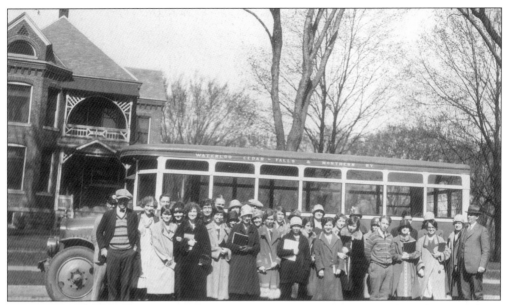

This group of students is getting ready to board a chartered Waterloo, Cedar Falls & Northern bus for a rural education observation tour. Professor Harry Eells, on the far right, heads the tour. The school's efforts in rural education won national recognition under the leadership of Macy Campbell.

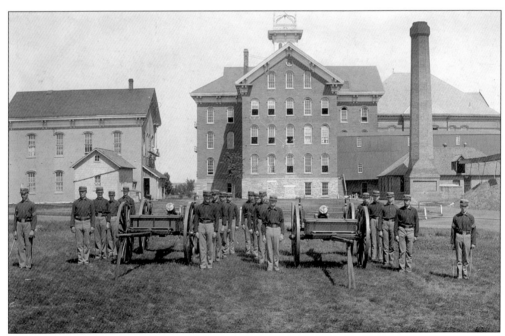

Students petitioned the faculty for military drill and training in 1889. In response, the school assembled equipment and hired an instructor. Nearly all men participated in the training. In this photo, taken on the current site of the Rod Library, an artillery company stands ready. In the center background is the west side of Central Hall. The two-story enclosed hallway behind the power plant allowed students to pass between buildings without going outdoors.

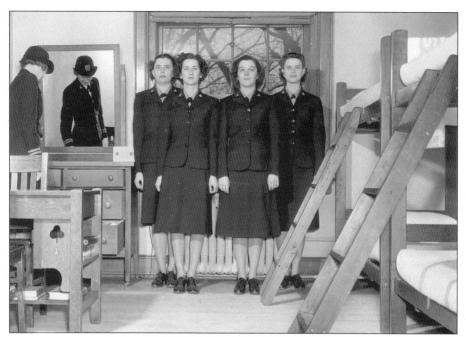

During World War II, WAVES units trained on campus. The initial groups took Basic Training; later groups took Yeoman's level training in secretarial skills. The WAVES were not Teachers College students, but they lived in the dorms and received instruction in the classrooms. In this Navy photograph, Lieutenant Margaret Disert inspects an enlisted women's room in the USS Bartlett.

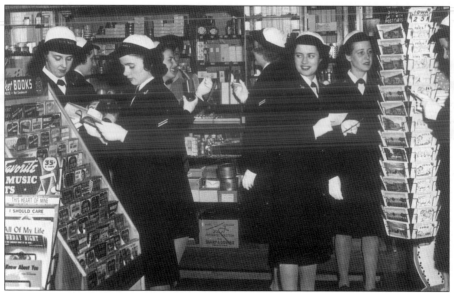

Over 12,000 WAVES took basic training on campus. Later, an additional 10,000 women received training in secretarial skills. The WAVES were busy almost the entire day with training and studies, but during their limited free time, they might visit Berg's Drugstore to check out magazine and postcard racks. This photo is from Bob Berg, owner of the corner store known to generations of students.

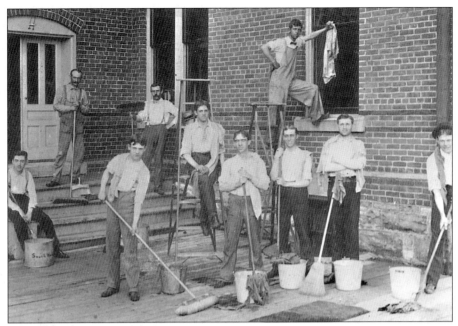

Even when tuition and other college costs were low, many students took jobs. Early students would often go to school for a term or two, drop out for a term to teach and save money, and then return to school. Sometimes students tried to find jobs relating to their intended careers, but that was not always possible. Here, in 1892, the student janitorial crew takes a break outside Old Gilchrist Hall.

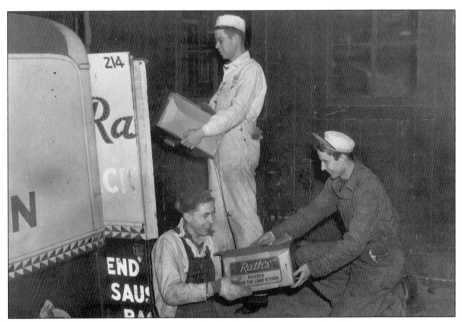

Students have traditionally worked on or near campus, but those with access to transportation often sought higher wages or different kinds of work off campus. This photo shows college students loading a truck at Rath Packing Company in about 1940; they are, from the left: Ernest Thompson (?), Robert Alexander, and Donald Henry.

From the Iowa Teachers Conservation Camp, through the environmental movement of the 1960s, and down to the present day, many UNI students and faculty have been involved in classroom studies and field work in environmental education. The Center for Energy and Environmental Education, funded by a federal grant, is witness to the strength of the program. In this 1991 photo, Conservation Club members clean up Dry Run Creek.

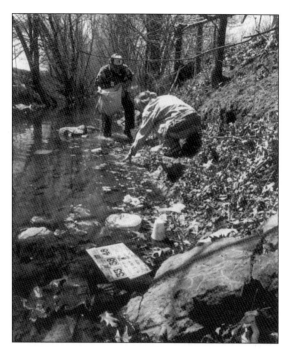

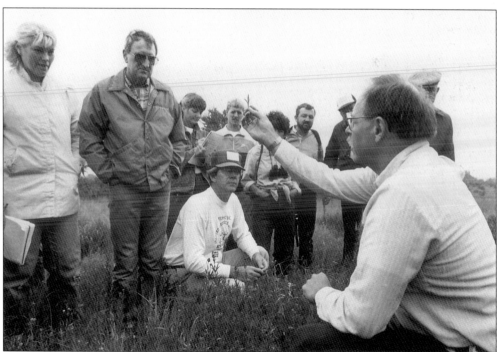

Distinguished teachers such as Melvin Arey, Laurence Palmer, Roy Abbott, C.W. Lantz, Corinne Harper, Martin Grant, Pauline Sauer, Virgil Dowell, Larry Eilers, and Ben Clausen have made UNI a leader in conservation education for a century. In recent years the university has also become a center for prairie restoration and roadside vegetation management. Here Professor Daryl Smith, in the foreground, continues that tradition in a class at UNI's Sand Prairie in 1989.

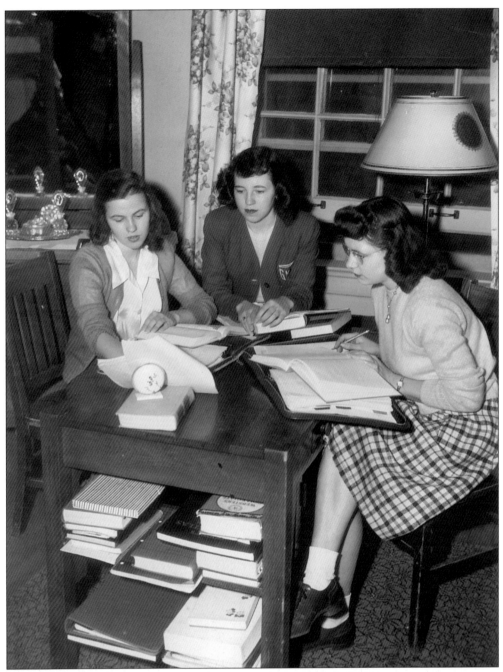

Peer advice cannot replace classroom instruction, but a great deal of learning goes on among students in informal settings. In places such as dormitories and the Union, students can relax and think about life's big issues, or, like these women, get together to work on class assignments.

Five

DEVELOPING THE CAMPUS

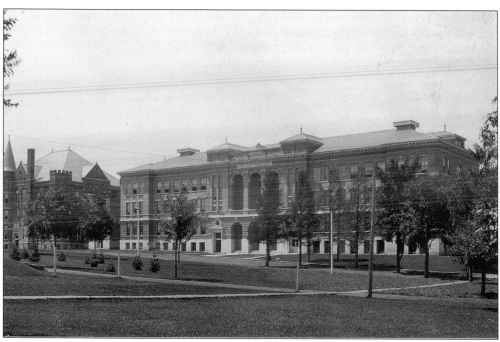

The Auditorium Building, now Lang Hall, was completed in 1901 at a cost of $120,000. A special train carried dignitaries from Des Moines to the building's dedication. The construction of this massive, costly structure was the final assurance that the Normal School, after 25 years of dedicated work, was a permanent fixture in the field of Iowa education. The building accommodated assemblies, performances, and classes for nearly a century before extensive renovations in 1999 and 2000.

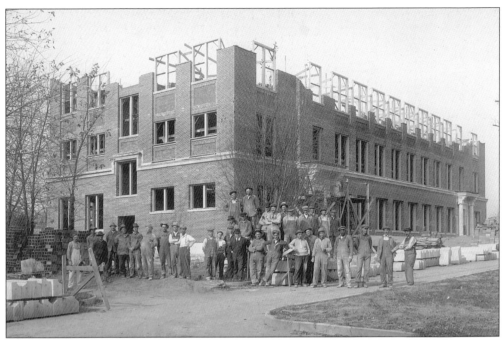

Wright Hall, completed in 1917 as the Vocational Building, was home to classes in agriculture, art, manual arts, and home economics. It was the last building in the construction boom funded by the state real property millage tax. The man with the coat and tie in the center of this photo is probably James Robinson, the architect who designed many campus buildings.

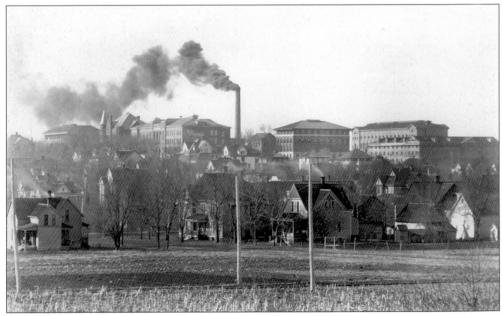

This is a look at the college from near 18th and Tremont Streets in about 1915. Even with the increasing number of houses on College Hill, the brick college buildings rising on campus are still impressive. The smokestack, certainly a prominent feature, would continue to billow clouds of coal smoke in the center of campus for another 20 years. (Courtesy Helen C. Portz.)

As early as the 1870s, Principal Gilchrist organized the students to plant and water young trees. This and similar efforts resulted in a shady campus with tree-lined walks. Unfortunately, nearly all of the trees were American elms. When the Dutch elm disease swept through Cedar Falls in the 1960s, it killed nearly 90% of the deciduous trees on campus. Though the original trees are long gone, the curved pathway from 23rd and College Streets to Lang Hall reflects Principal Gilchrist's early plantings.

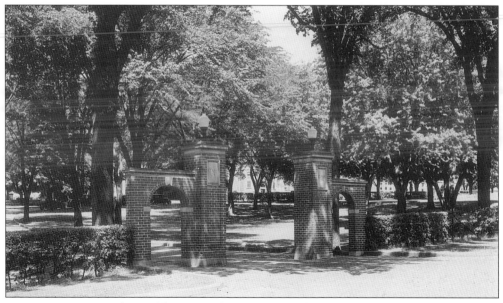

Decorative gateways, donated by senior classes, once marked the eastern entrances to campus. The 23rd Street and Seerley Boulevard gateways commemorated the successful conclusion to the Coordination Controversy, which would have limited the school to a two-year curriculum. The beautiful gateway pictured here, donated by the Class of 1914, once stood at the 26th Street entrance.

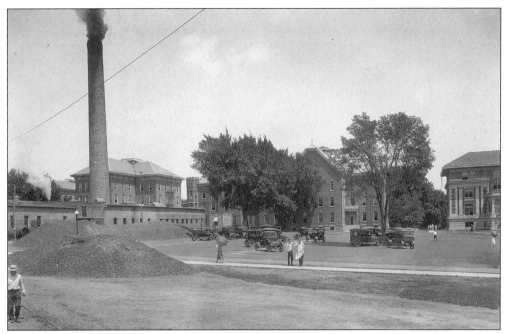

The power plant, with its coal piles, cinders, machinery, and railroad tracks dominated the current site of the Maucker Union until the middle 1930s. Faculty and students complained about the smoke and dust from this operation for many years. It does look, however, as if a student could find a good parking place on this sunny day in the 1920s.

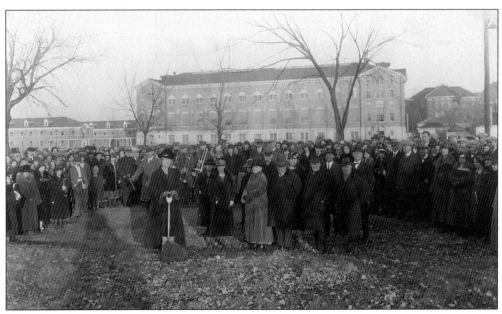

World War I interrupted alumni plans to build a memorial on campus. After the war, plans coalesced around a tall bell tower, or Campanile. With the college band on hand, Mrs. David Sands Wright, a member of the Class of 1880, turns the first shovel of earth for the Campanile on November 18, 1924. This groundbreaking seems to be a little north of the actual site of the Campanile.

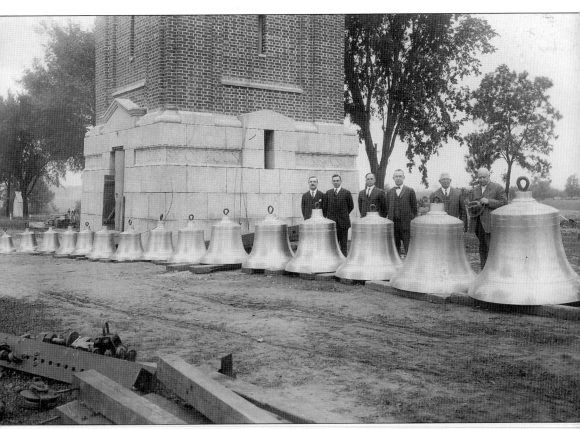

Each bell of the original 15-bell chime was dedicated to a person or group associated with the college. On the right, President Seerley stands behind his bell, the President. Homer Culley, a grandson of the president, was 11 years old when he visited campus and saw the bells on the ground awaiting installation. He later recalled crawling under the biggest bell and swinging the clapper against the side "much to the disadvantage of my eardrums." The size of these 15 bells is impressive, but the small number limited the musical repertoire. In 1968, the UNI Foundation replaced damaged bells and added new bells to make the chime a 47-bell carillon. Standing behind the bells, from left to right, are: bell manufacturers J.F. Behlert and A.E. Meneely, business manager Benjamin Boardman, Alumni Director A.C. Fuller, Superintendent of Buildings and Grounds James E. Robinson, and President Seerley.

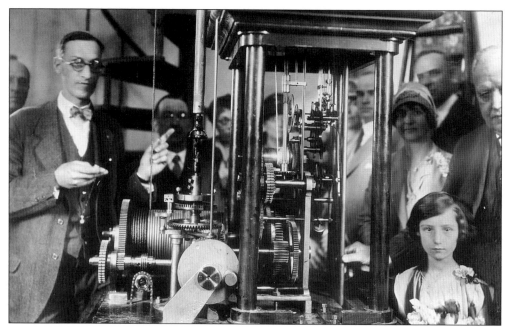

Charles Fasoldt built a clock mechanism and displayed it at the Centennial Exposition in Philadelphia in 1876, where a young Homer Seerley saw it. Fifty years later, the Teachers College won a contest to provide a suitable home for the clock in the new Campanile. Here Charles Fasoldt's grandson Dudley, standing on the left and holding a watch, prepares to start the mechanism on May 30, 1927. President Seerley is at the extreme right, and the little girl is Ethel Fasoldt, Dudley Fasoldt's daughter.

During the 1920s, the college acquired a second 40-acre plot west of the original 40-acre campus. This meant that the campus stretched from College Street to Hudson Road and from 23rd to 27th Streets. The new land provided room for additional buildings, athletics facilities, and recreational areas. In this photo, men with teams of horses level land near the current site of Lawther Hall.

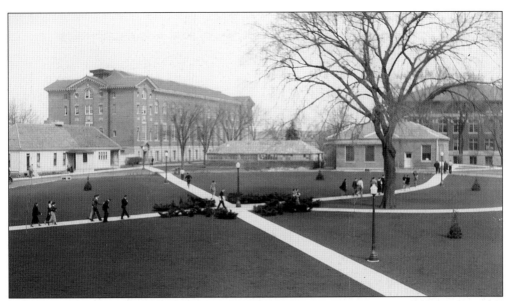

President Latham undertook a number of landscaping projects with special attention to the Campanile and to the area pictured here, the former site of the coal pile and a cinder parking lot in the center of campus. Students and faculty quickly grew fond of this new green space with its majestic elm, and many protested when this circle was cleared to make way for the Maucker Union in 1967.

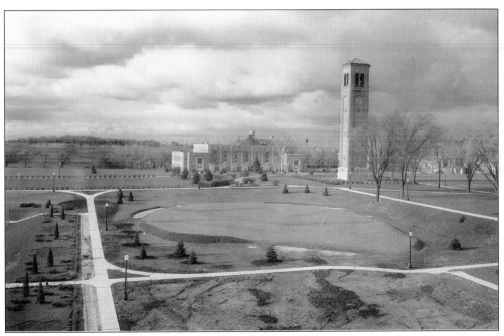

Beginning in the late 1920s, the college started to develop the land west of the Campanile. The Commons, in the background, served as the union for students of that day; it provided a place for them to relax, get a snack, and enjoy dances and other entertainment. In the foreground is a large putting green for physical education classes. Some of the newly-planted spruce trees in this photo survive today.

By the 1930s, a new power plant was essential to the development of the college. The old plant was antiquated; President Seerley had earlier feared that a breakdown could close the school. In addition, the old plant could not produce enough steam for the new men's dormitories, the Commons, and the first phase of Lawther Hall. Like other new campus buildings of this period, the power plant and the associated physical plant structures showed strong Art Deco architectural elements.

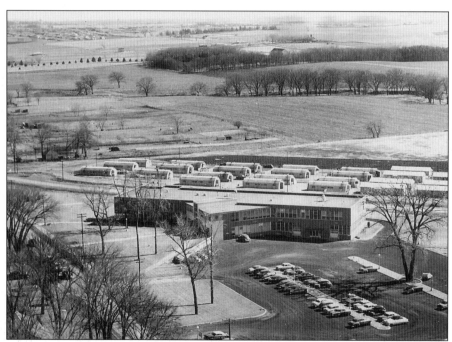

Latham Hall, completed in 1949 as the Arts and Industries Building, was the first substantial postwar campus construction project, but behind Latham Hall and just across what is now University Avenue are the Quonset huts of Sunset Village. Acquired at a bargain price immediately after the war as surplus property, these units helped meet the demand for postwar family housing. Life in Sunset Village became the stuff of alumni legend.

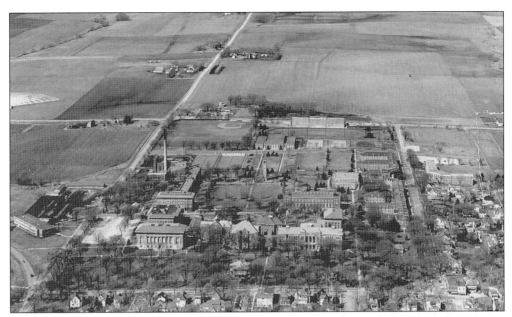

This is a clear look at the campus from the east in the early 1950s. Buildings have spilled across both 23rd and 27th Streets, but the center of campus is still fairly open. In the distance, O.R. Latham Stadium and the baseball field abut Hudson Road, and an outdoor theater is barely visible at the left where physical plant buildings now stand. The campus would change radically by the middle 1970s.

When it opened in 1962, the music building, later named to honor Myron Russell, provided a welcome new home for music students who had been taking their lessons in deteriorating Old Central Hall. Russell Hall provided classrooms, practice rooms, and a large auditorium. Here students enjoy a concert in the bandshell on the south side of Russell Hall in 1978. Professor David Delafield designed the artwork, "Gregorian Chant," which adorns the bandshell.

With the opening of the Education Center in 1972, education students and faculty finally had a facility of their own. The new building featured large lecture halls, the Curriculum Laboratory, many classrooms, faculty offices, and a state-of-the-art audiovisual system. The building was later named for alumnus Alvin Schindler.

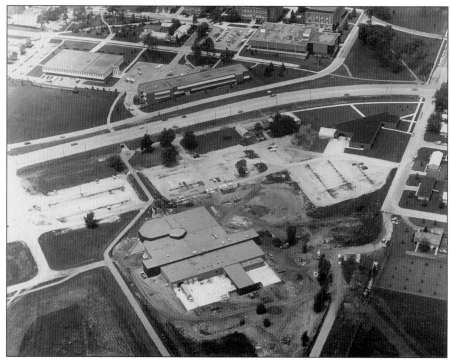

In recent years, many College of Natural Sciences activities have been concentrated in the southeastern corner of campus. This 1975 photo shows the Industrial Technology Center nearing completion. Note that 27th Street is no longer a through street--all traffic needed to turn onto University Avenue.

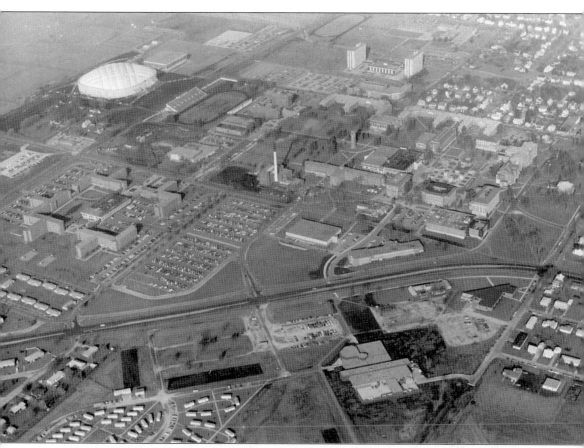

The Physical Education Center and the UNI-Dome, seen in the upper left of this 1976 shot, continued college development west of Hudson Road. The UNI-Dome, completed in 1975, was a controversial project opposed by those who preferred a fine arts auditorium and those who opposed the use of student fees for athletics facilities. Supporters of the project prevailed, and the Dome has been used for athletics, concerts, commencement, tractor pulls, trade shows, and many other events.

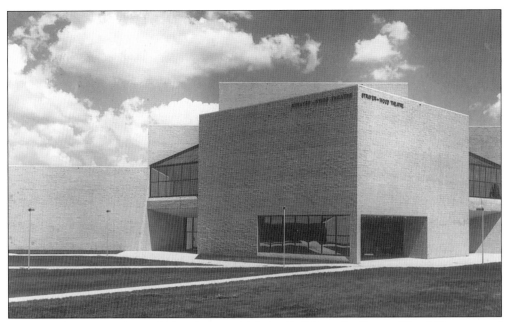

The Speech-Art Complex includes the Kamerick Art Building, the Strayer-Wood Theatre, and the Communication Arts Center. This complex, completed in stages between 1978 and 1985, brought together classrooms and facilities for several departments of the College of Humanities and Fine Arts. The architectural style was a considerable departure from the traditional red brick and limestone of other campus buildings. Pictured here in 1981 is the Strayer-Wood Theatre, named for Professors Hazel Strayer and Stan Wood.

Enrollment in business curricula climbed dramatically in the late 1970s and 1980s. The Business Department became a School; then the School became a College. The program rapidly outgrew Seerley Hall. Not until 1990, though, did the College of Business Administration move into its new building on the former site of the power plant and Prexy's Pond. In 1998, the Business Building was named to honor former President Constantine Curris.

Six

LIVING AWAY FROM HOME

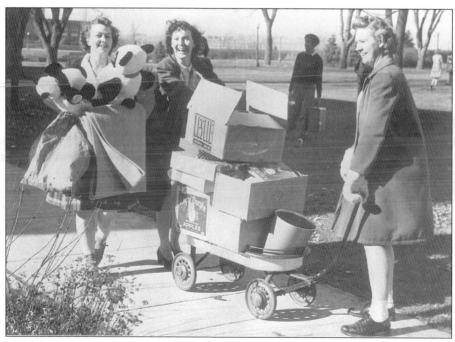

Going to college usually means living away from home, and moving into a new place can be a lot of work for students and their families. Sometimes, though, carrying boxes and furnishings serves as a welcome distraction from the upcoming goodbyes when the family leaves for home. These women seem to be having fun in the days when college students could move their goods in an old coaster wagon. They are part of the group that moved out of Bartlett Hall to make room for military personnel during World War II.

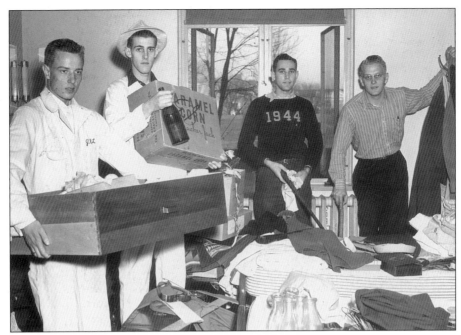

These men are involved in the same World War II housing shift as the women with the coaster wagon, but they do not seem quite so happy or well-organized. Maybe they are being more realistic about the prospect of four men living in a room meant for two. Just 76 men, of a total of 820 students, were enrolled in the fall of 1943 when this photo was taken.

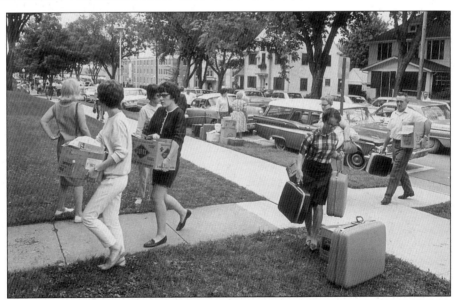

The streets are jammed, parents are sweating, and students are looking for friendly faces. It happens every year. These students are moving into Bartlett Hall in 1965. Their gear, packed in suitcases and boxes, looks manageable. In contrast, many dorm residents of the 1990s would bring small refrigerators, microwave ovens, loft beds, stereo systems, TV-VCRs, computers, and upholstered furniture. What was formerly packed into Mom and Dad's car may now require a rented truck or borrowed trailer.

The earliest Normal School students lived in the school's boarding department on campus or in rooming houses downtown. When the school closed its boarding facilities in 1892 to provide more classroom space, rooming houses sprang up on College Hill. Some of the houses took in large numbers of students and were well-known to generations of Normalites. This is the J.C. Aldrich house.

This group of students from about 1895 poses on the porch of Rownd Hall, a facility operated by the William Rownd family. Robert Fullerton, who would later serve on the music faculty, is seated just right of the post at the top of the steps. Some houses lodged only women, and some just men. Rownd Hall must have included both. With no paved streets around Normal Hill, the student with the bicycle must have had some very rough riding.

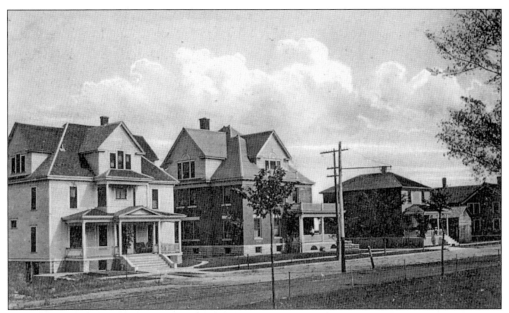

This row of large rooming houses was located adjacent to campus on 23rd Street. The large brick house in the center, 917 W. 23rd Street, survives at this writing just a little east of University Book and Supply. At one time it housed Alpha Delta Alpha fraternity, and in more recent times the lower front level has been a bookstore and a dry cleaner. College officials such as Dean of Women Marion McFarland Walker inspected rooming houses and prepared lists of approved facilities.

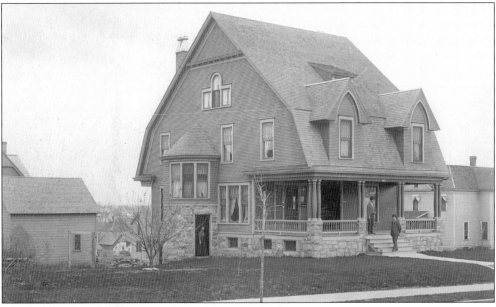

Some faculty members took in roomers in their new homes on the Hill. This handsome building belonging to Professor Leonard Parish was located on the northwest corner of Olive Street and Seerley Boulevard. It still houses students today, a century after it was built. As late as the 1920s, students paid about $2 a week for a room on College Hill. Meals at a boarding house cost less than $1 per day.

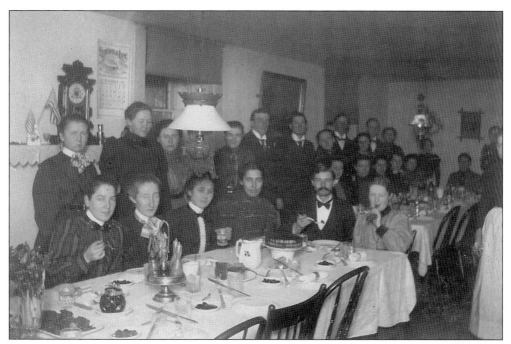

As early as 1879, the student newspaper joked about college food; a student is quoted as saying that he respected great age in people, but he was less respectful when great age appeared in the form of a tough steak from an ancient steer. Here, the Rownd Hall dining room, apparently located in the basement, certainly looks pleasant, and the well-dressed boarders seem ready to start their meals.

Gathering in a friend's room to relax, talk, and laugh is a longstanding tradition among college students. These students in Rownd Hall seem to be having a good time. Note the large collection of photos on the walls. The photos on both sides of the mirror look like exchange photos from friends, and the photos near the ceiling appear to be fashion illustrations.

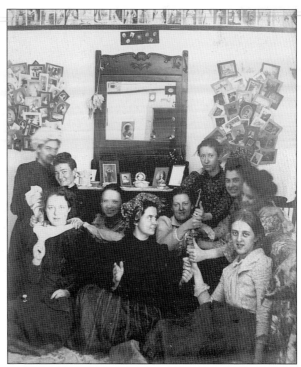

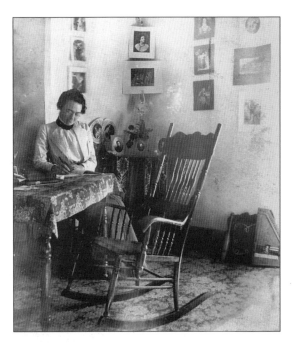

This young woman is studying or perhaps writing a letter in her room at Rownd Hall in the 1890s. She is wearing spectacles, perhaps to help ward off the "eye trouble" that sent so many Normalites home after a brief stay at the school. Note also the Indian club, the small pillow or cushion, and the autoharp in the lower right. This student probably embroidered her name and her year in school on the pillow case.

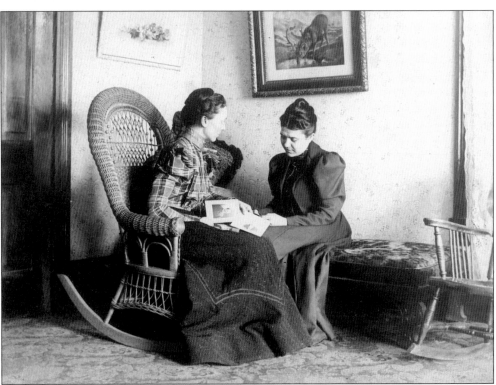

Mary Achenbach and Nellie McAlvin compare photos in the parlor of Rownd Hall in about 1893. To modern sensibilities, this may seem like a very gentle pastime. However, limited transportation, college regulations, and the mores of the day meant that students, especially women, tended to spend most of their time close to campus.

Mail is an important part of just about every student's daily routine. Before E-mail or convenient access to telephones, mail was the primary way to receive news from home, with perhaps a few dollars enclosed, or it could also mean a letter from a sweetheart. These men are checking what the postman has brought to Bates Hall, a rooming house on Walnut Street in 1926. (Courtesy Kenneth Stolze.)

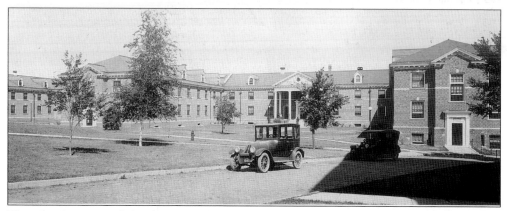

The school re-entered the dormitory business when the first wing of Bartlett Hall for women opened in 1915. Rooming house operators strongly opposed this move, but school officials believed it was the best way to assure that women lived in secure, sanitary conditions. Parking did not seem to be a problem for the owner of the Franklin automobile on the brick drive south of Bartlett Hall a little after 1924.

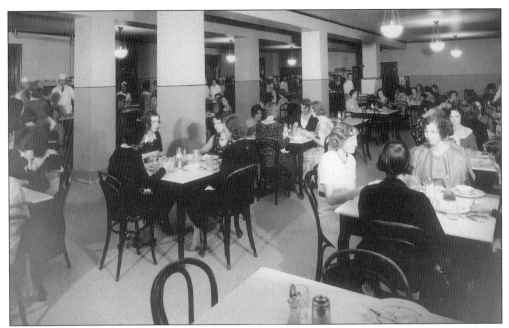

In this 1932 photo, the Bartlett Hall east wing cafeteria, with its small tables and bentwood chairs, has the pleasant atmosphere of a tearoom. Strict dining facility dress codes and careful attention to manners helped to create this atmosphere.

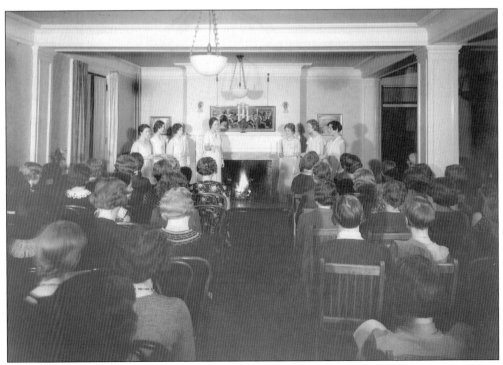

Dormitories developed traditions analogous to those practiced in Greek organizations. These traditions tended to foster fellowship, continuity, and group unity. These students are taking part in the hearth-lighting ceremony in Bartlett Hall in 1932.

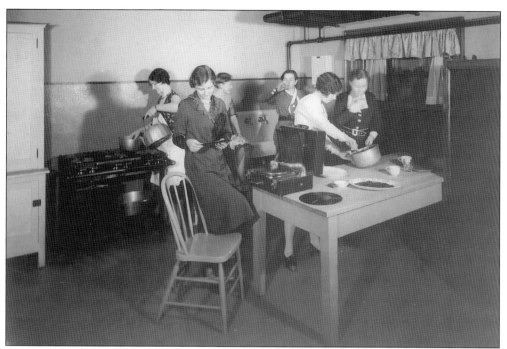

College students have always found ways to enjoy themselves in the dormitories. Here some women cook up snacks and enjoy records on a wind-up phonograph in 1932.

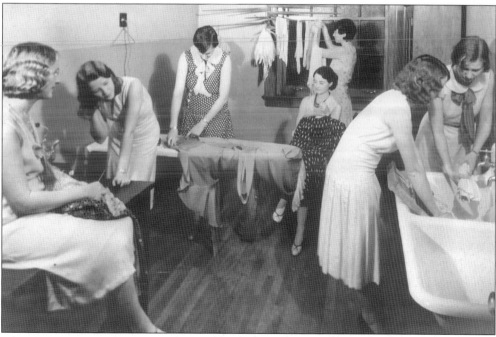

Modern fabrics, informal dress styles, and ready access to automatic washers and dryers make doing laundry fairly easy for today's students. But it was more complicated for these students in 1932 as they rinse, dry, and iron some clothes in Bartlett Hall. Dry cleaners and commercial laundries near campus did a thriving business.

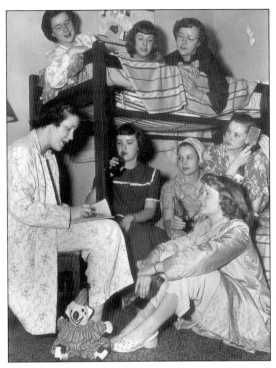

In this shot from a 1949 student guidebook, Corky Coed's Code, students relax at a pajama party. This guide was full of advice on all aspects of a coed's life. About clothing it said, "If the weather is extremely cold, profs will endure well-pressed slacks." On dating, the code advised a young woman to let her escort "be the he-man he wants to be" and allow him to open doors and help with her coat.

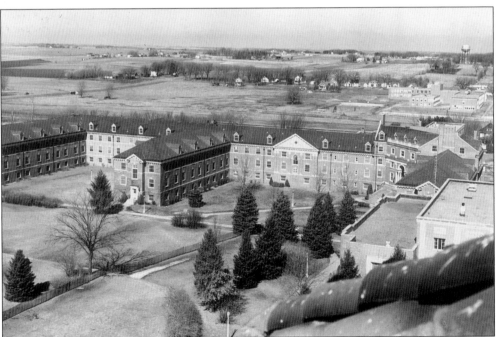

Lawther Hall is well-known as the home of Augie the Ghost, a restless spirit who reputedly haunts the building's attic. Campus legend has it that Augie was a soldier who died in an infirmary in Lawther Hall, though there is no evidence to support this contention. Hall residents have capitalized on this reputation by sponsoring a "haunted house" around Halloween. This 1956 shot shows Price Laboratory School, without its fieldhouse, in the right background.

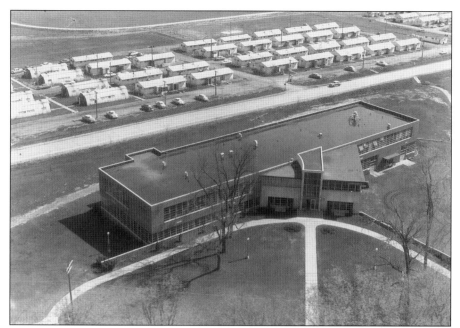

When the GIs returned to college after World War II, many brought families with them. The housing situation for these families was critical. The college hastily built both Quonset huts and more traditional housing units near the current site of the Industrial Technology Center. Conditions were crowded, but students were happy to find just about any place to live. Even when Sunset Village finally closed in 1972, some students protested the loss of this low-cost housing.

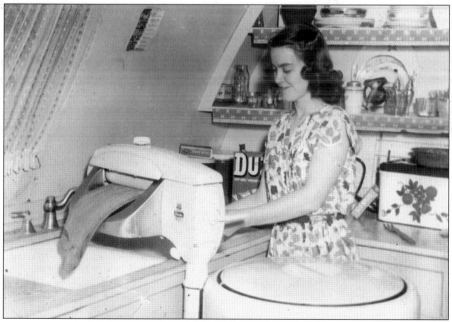

Students who lived in Sunset Village worked hard to create a community. They organized clubs, cared for each others' children, and even set up a cooperative grocery store. This young wife wrings out her laundry in the crowded but neat kitchen of a Quonset hut in Sunset Village.

Postwar housing was so tight that this enterprising student converted a chicken coop into living quarters. This is probably returning GI Douglas Brown who, with hometown buddy Richard Skilling, lived in this tiny house on land rented from a farmer just west of Hudson Road in 1945-1946.

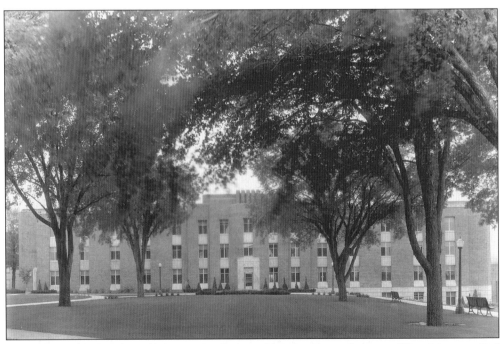

Baker Hall, completed in 1936, was the first modern dormitory for men. What is now called Baker Hall was originally built as two separate buildings that were joined by an addition in 1958. Baker Hall featured many strong Art Deco architectural elements in its design, some of which survive today.

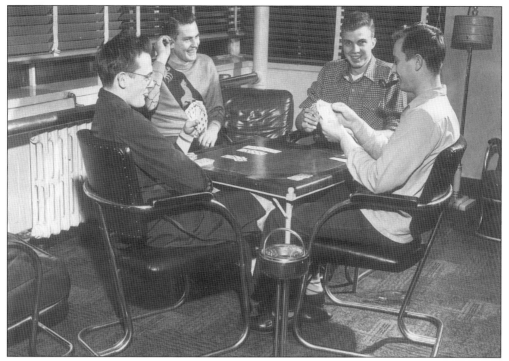

Playing bridge or hearts in the lounge has long been a favorite pastime for dormitory residents. Marathon games have been known to transcend the call of meals, sleep, and class. This group seems to be having a good time in 1950; they are, from the left: Dick Braunschweig, Bob Paul, Jim Ludeman, and Bill Nettleton.

When the first unit of Campbell Hall was completed in 1951, it was intended to be home to about 300 junior and senior women. An addition in 1964 doubled the building's capacity. This residence hall was named to honor Dean of Women Sadie Campbell.

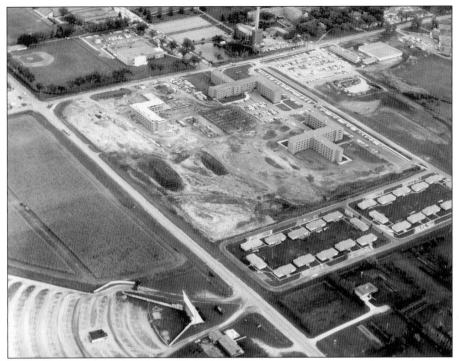

The dormitory system expanded to meet soaring enrollment in the 1960s. Construction on the Regents Complex of four dormitories began in 1960 and ended in 1967. This photo was taken in about 1964 before construction on Noehren Hall had begun. Note the College Courts married student housing units in the lower right and the outdoor theater on the current site of 31st Street.

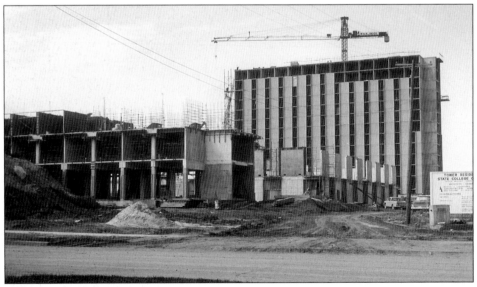

The next big dormitory project was the Towers Complex. Here Bender Hall nears completion while the dining center and Dancer Hall still have a long way to go. The high-rise dorms were completed in 1969 and housed a total of about 1200 students. A third unit was planned for the Towers Complex, but enrollment reached a plateau and the third unit was not built.

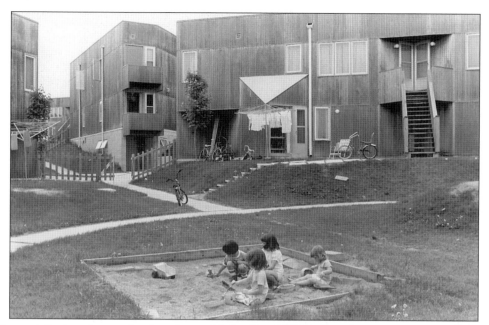

To meet the housing needs of students with families, UNI developed an apartment complex on a rise south of University Avenue. Some apartments were available in 1971; the entire complex was completed in 1972. With the completion of the Hillside Courts complex, the last units of Sunset Village were closed. Hillside Courts provided about 248 units of affordable housing close to campus. Students' children play in a sandbox in this 1977 photo.

The ROTH (Residence on the Hill) complex was completed in 1994 in the far southeast portion of campus to provide students with suite and apartment-style living space. ROTH houses nearly 400 students in living units of several sizes. The wings of the building were named for John Eiklor, Mavis Holmes, Anna McGovern, and Daryl Pendergraft. (Courtesy Tim Wiles.)

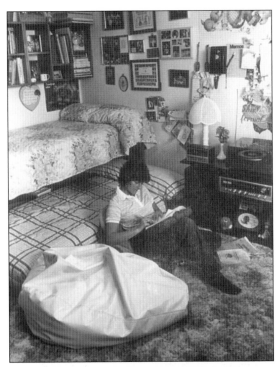

This residence hall dweller from 1981 has clearly worked hard to use her space efficiently and to make her room comfortable. Modern students have a great deal more equipment and furnishings than did their rooming house predecessors, but both groups seem to enjoy having photos of family and friends around them.

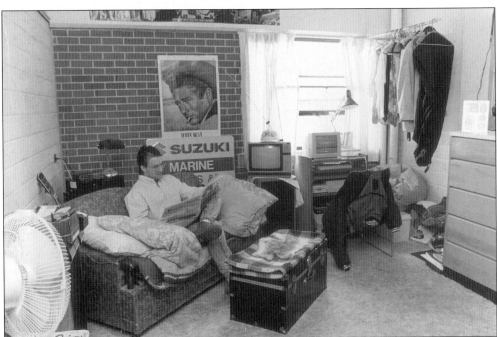

By the early 1990s, personal computers became more common in student living quarters, where students used them for word processing and statistical work. By the late 1990s, dorm rooms were linked to the campus computer network and the Internet. With more and more information available via the World Wide Web, students could conduct a great deal of their research from their rooms. This is a nicely-equipped, utilitarian student room, possibly in Shull Hall, in 1991.

Seven

HAVING FUN

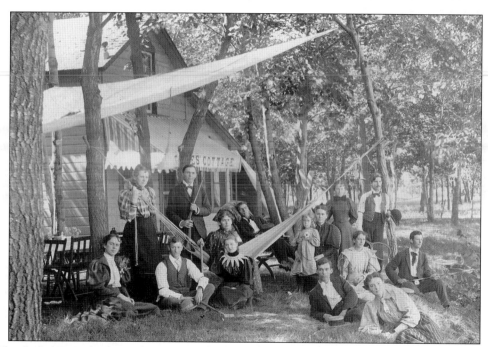

The Cedar River, both north and south of Cedar Falls, has always been an attractive place for recreation where students could walk, swim, picnic, and go for boat rides. In the early days, mixed groups of men and women required chaperones, and school authorities punished unescorted groups for mildly scandalous behavior. This group, with a small-caliber rifle, fishing rod, croquet mallet, and tennis racket, seems to be enjoying a pleasant day at a commercial cottage on the river.

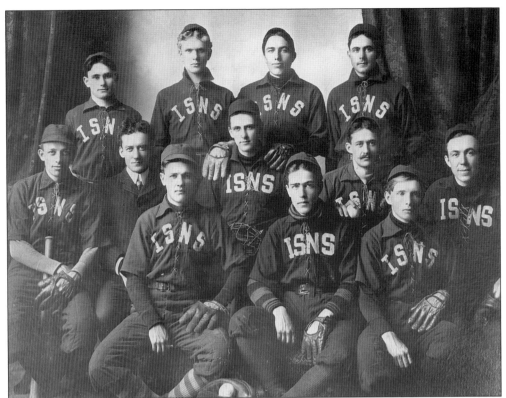

Baseball was probably the first competitive sport played on campus. Professor Wright notes that in the spring of 1879 the school played three games against the Cedar Falls boys and "got beaten just three times." Football started a few years later. The team in this photo is probably from about 1895.

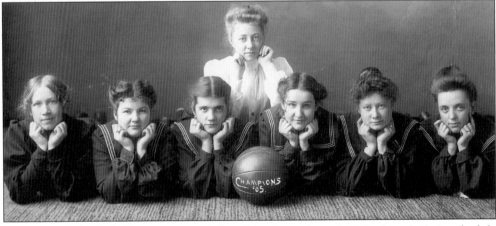

This women's basketball team was undefeated in the spring of 1905, though their schedule was limited to just two games against teams from Waterloo. The winning scores were 6–3 and 10–0. They are, from the left: Johanna Johnson, Georgia Knight, Helen Seerley, Coach Emma Paffendorf, Captain Winifred Muhs, Mabel McNally, and Ethel Vinall. Helen Seerley was a daughter of the president. Mabel McNally later married Joe Wright, son of David Sands Wright. (Courtesy Robert Muhs.)

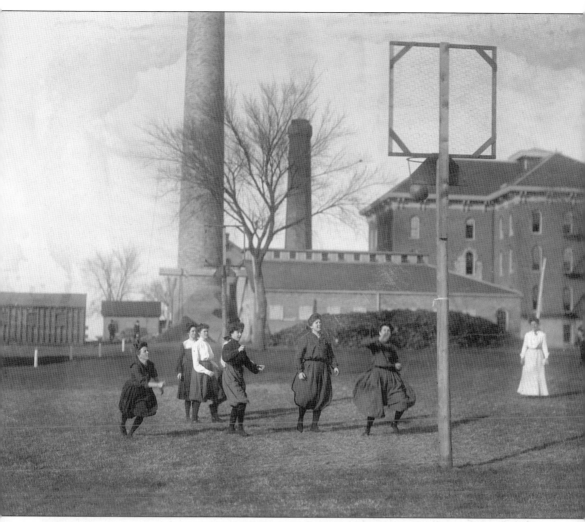

Women have participated in sports and physical activities since the early days of the school. Maude Gilchrist organized a women's gymnastics club in the middle 1880s, and despite the crude equipment, this group of women certainly seems to be having a good time playing basketball in about 1904 on a site now occupied by the Maucker Union. Miss Emma Paffendorf is most likely the woman supervising the activity on the right.

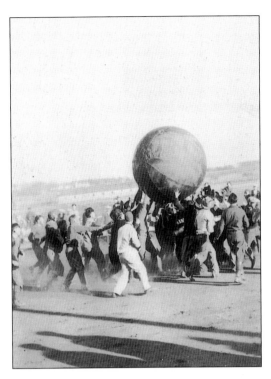

Rivalry between classes, including some mild hazing directed toward freshmen, was a significant social force for much of the school's history. This photo shows a pushball contest between freshmen and sophomores at the fairgrounds east of the intersection of Main Street and Seerley Boulevard in 1926. A participant said that no one actually won such contests; everyone just got too tired to continue. (Courtesy Kenneth Stolze.)

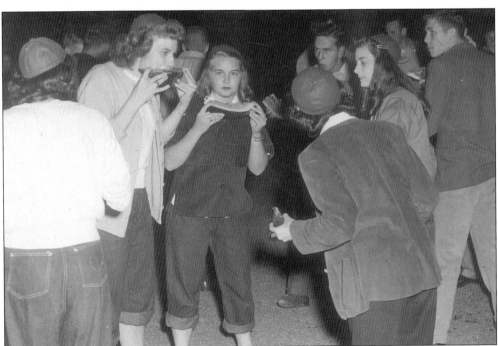

Getting students together for a "feed" of some sort is a long tradition on campus. Sometimes it was chili, sometimes ice cream, and quite often watermelon. Frequently these feeds were part of new student orientations. Here a group of freshmen, still wearing their beanies, enjoys melon wedges.

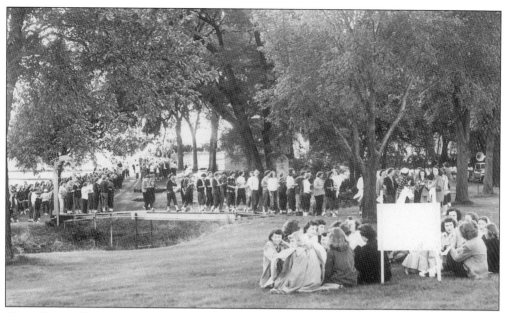

The college golf course was a favorite site for large picnics, because it provided a pleasant, shady spot close to campus. These new women students enjoy the traditional Chuck Wagon Picnic sponsored by Associated Women Students in 1949. The women played mixer games and sang Western songs before enjoying supper and a bonfire.

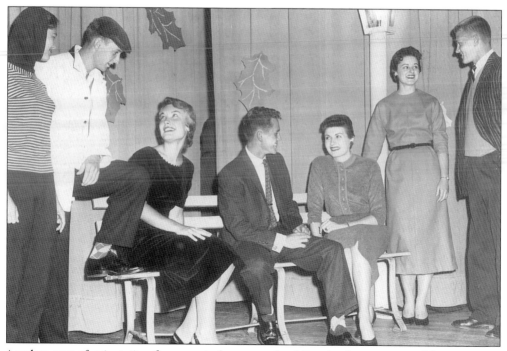

Another part of orientation for new students was the fall style show sponsored by Associated Women Students and Men's Union. The program presented the significant upcoming events on the college calendar by means of student models dressed in appropriate clothing for the occasions. These are some of the models for the 1956 show.

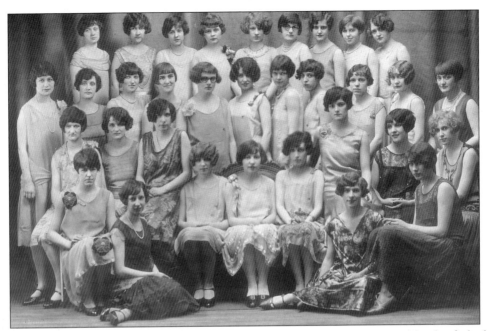

The status of Greek societies on campus was ambiguous for many years. Board rules forbade them, but the school administration was unwilling to enforce the rules. Consequently, and discreetly, the societies grew, especially after World War I. Greek society pictures began to appear in the Old Gold in the 1920s, and some fraternities even maintained their own off-campus houses. This is Sigma Tau Delta sorority in 1925. (Courtesy Keith Remy.)

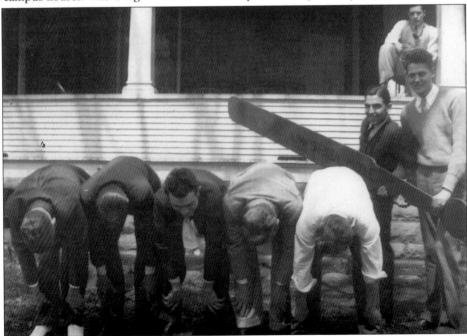

One can only speculate on the infraction that brought out the official paddle to train these recalcitrant pledges. The lettering on the paddle indicates that these are the men of Alpha Delta Alpha. The site appears to be the front yard of the fraternity house at 917 W. 23rd Street.

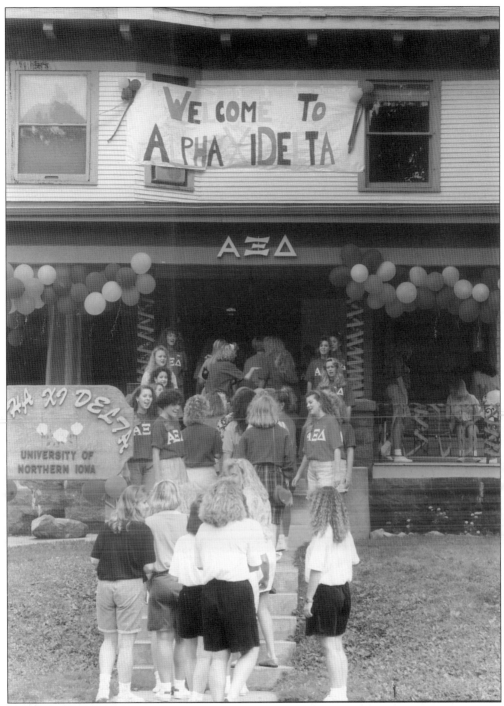

Interest in Greek societies has waxed and waned. In the late 1960s, Greeks were censured by some for being out of touch with the serious issues of the day. In recent years they have enjoyed greater tolerance and stability. Here the women of Alpha Xi Delta welcome potential pledges to their house at 2410 College Street.

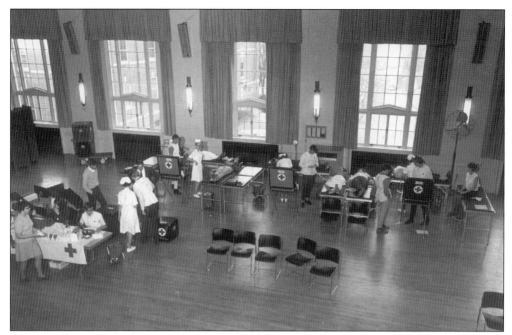

Greek societies have a tradition of philanthropy. They typically engage in a variety of community service projects. In one longstanding effort, Sigma Alpha Epsilon and its predecessor Alpha Chi Epsilon have assisted the Red Cross with on-campus blood drives for many years. This drive took place in the Commons in the middle 1960s.

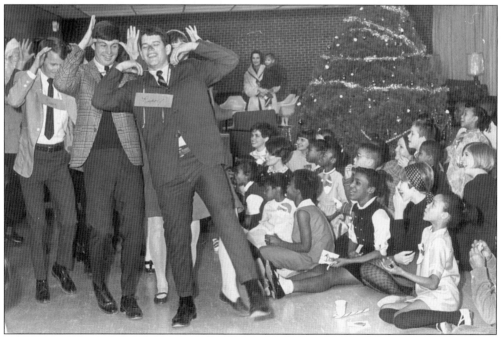

Without the label reading "Rudolf" pinned to the young man in the dark suit, this photo might be difficult to interpret, but with this misspelled hint, it becomes clear that Santa and his reindeer are putting on a Christmas show for local youngsters. This was a joint Greek effort in 1968.

114

Campus religious centers representing many faiths sprang up around campus. The centers held worship services, organized service projects, promoted fellowship, and provided social activities for students. Here a group of students, probably from the Lutheran Student Association, is headed for a picnic in the fall of 1946.

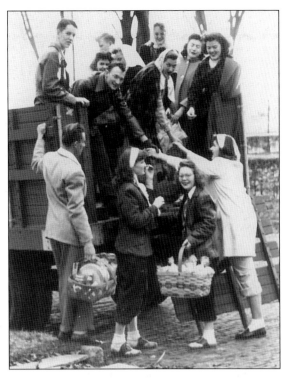

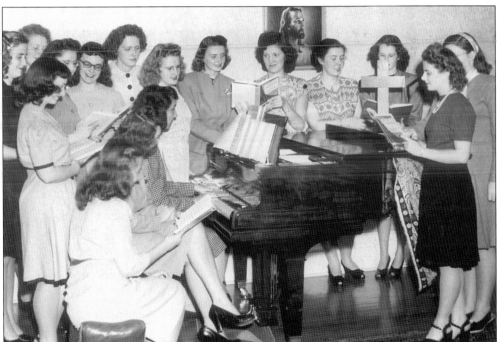

Some student religious groups had formal patterns of pledging and initiation. Prospective members would learn about the local chapter and national organization, memorize club songs, and take part in meetings and discussions before becoming full members. The women in this 1946 photo are members of Phi Chi Delta, the Presbyterian sorority.

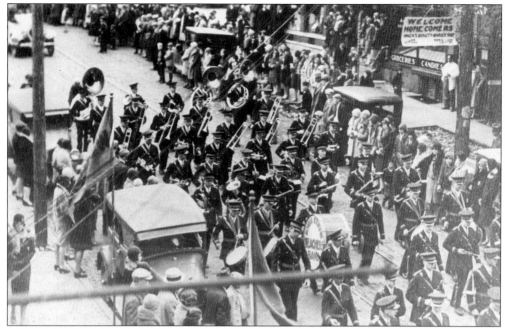

The school celebrated its first Homecoming in 1920. The celebration quickly evolved into the well-known format—a parade, entertainment for students and alumni, and a football game. Here, with Berg's corner in the upper middle, interested spectators watch the band as it marches down College Hill in October 1929, just two weeks before the Wall Street Crash.

On the Friday before Homecoming, cheerleaders and band members marched across campus and in and out of buildings urging students to leave class and join them for a Skip Day. Here a pep band gathers students at Berg's corner for a rally. This shot offers a good look down College Street. Most of the buildings survive, but all of the businesses have changed.

For Homecoming in 1953, these faculty and students put together a pep band of their own to fire up the crowd. They are from the left: unidentified sousaphone player, Myron Russell on clarinet, unidentified piccolo player, unidentified euphonium player, Karl Holvik on clarinet, Charles Maxwell on trombone, William Latham on trumpet, Dave Kennedy on trumpet, Martin Nelson and Daryl Pendergraft on bass drum.

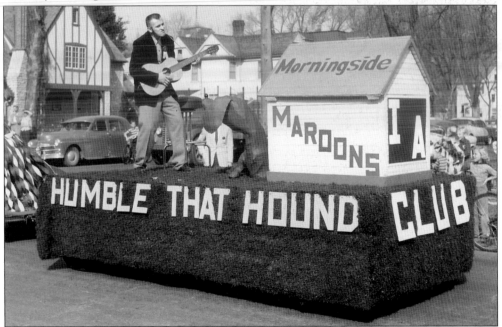

Cedar Falls is seldom in the cultural vanguard, but this must be noted as a very early appearance of an Elvis impersonator—Homecoming, 1956.

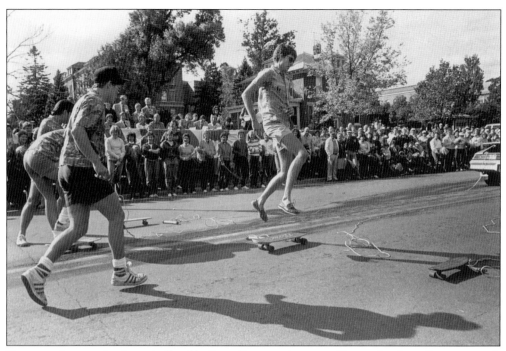

Homecoming parades have declined in formality over the years. Here a skateboarding team with towropes tied to a car passes the reviewing stand on 23rd Street in 1983.

A tradition associated with Homecoming is campaniling—that is, kissing one's date under the Campanile at midnight. Many of these students in 1980 seem to be serious about honoring the tradition.

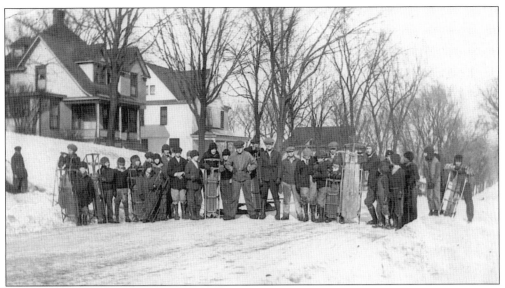

Since at least the 1880s, students enjoyed sledding on the slopes surrounding College Hill. These college students and local children are gathered on Tremont Street in 1927. A rooming house resident said, "All you needed was heavy clothing and a Flexible Flyer!" (Courtesy Kenneth Stolze.)

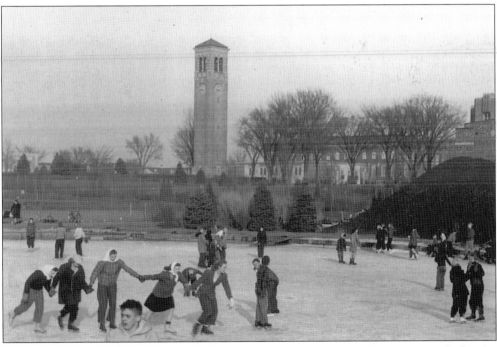

Students enjoyed a variety of recreational activities on Prexy's Pond, a shallow pool of water located on the current site of the Curris Business Building. In the summer, students paddled canoes there. On warm spring nights, it was a place for serious horseplay and midnight dunkings. In the winter, students skated and played hockey. In its later years, Prexy's Pond was often overgrown with cattails and polluted by coal pile run-off.

119

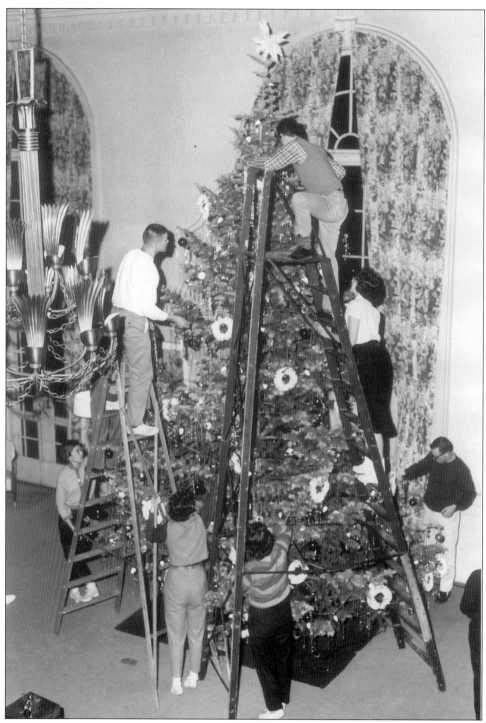

Most students enjoy holidays like Thanksgiving and Christmas at home, but they often celebrate beforehand on campus to relieve stress and get into the holiday mood. Many of them sing carols, go to parties, and participate in the tree-lighting ceremony. These students are decorating a large tree in the Commons in 1960.

May Day was an important spring celebration with parades, Maypole dances, and a Queen of the May Carnival. This 1913 celebration was special. It marked the successful resolution to the Coordination Controversy, which would have turned the school into a two-year institution. Students and faculty here give thanks and enjoy the day. Mrs. G.W. Walters was queen of this celebration.

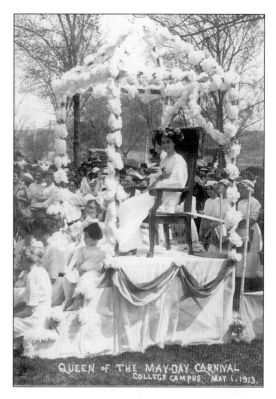

QUEEN OF THE MAY-DAY CARNIVAL
COLLEGE CAMPUS MAY 1, 1913.

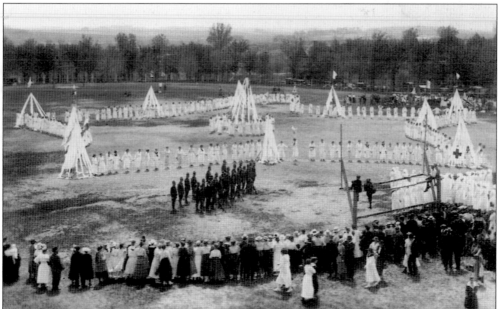

The 1918 May Day celebration included a "patriotic demonstration" to show that the college was involved in the war effort. Many students were in military service, and others were training on campus. In this picture, women in white have arranged themselves into the shape of a star. A group of soldiers stands in the foreground, and on the right is a Red Cross group. Later in the day, there was a machine-gun demonstration at the fairgrounds. (Courtesy David T. Jones.)

121

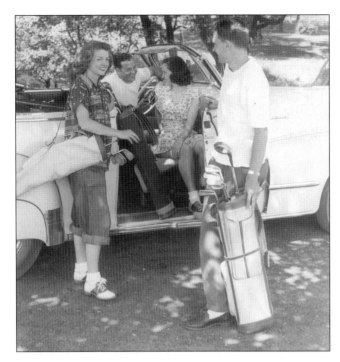

These students, pictured from the left: Mary Elderton, Jack McCabe, Beth Chapler, and Nick Braden, are likely headed to the college golf course for an afternoon of fun. The golf course was a gift from Mr. and Mrs. Charles Rownd in 1925. Both students and faculty enjoyed this quick nine-hole course just a few blocks east of campus until the state purchased the land to build Highway 58 in 1991.

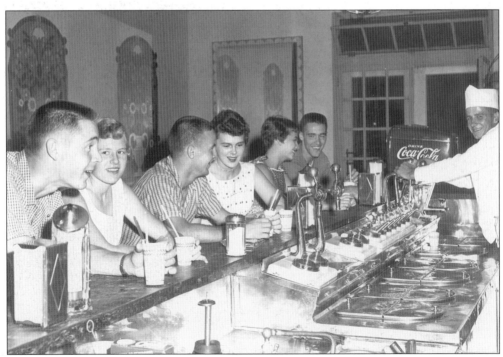

Until the Maucker Union opened in 1969, the Commons served as the major student recreation building. The large upper-level rooms provided dignified settings for dances and receptions. The south balcony was a pleasant place to relax in the sun. The Fountain Room, though, was a real student favorite. Here three couples enjoy treats in the middle 1950s.

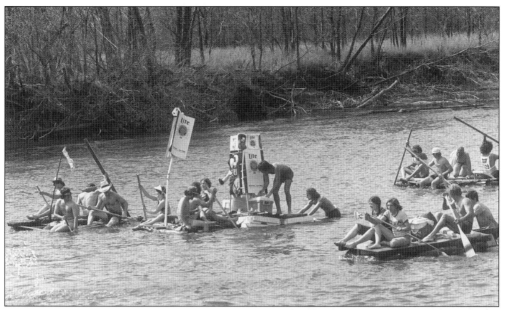

Spring celebrations persisted, but the activities changed radically. This is the student regatta on the river during SUNI-Days in 1977. If you look closely at the sign on the boat sailing second from the left, you might get an idea of what fueled some of these mighty craft.

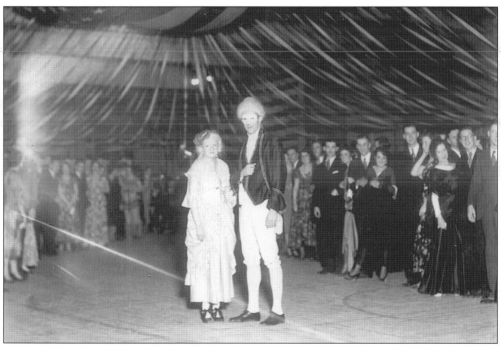

The morality of social dancing was a serious issue for many people in the United States at least until 1920. Only after years of debate did the college approve social dancing at college events; however, once dancing was permitted, students began to hold dances for many occasions. By the 1930s, there was a dance of some kind nearly every week. George and Martha are ready here to receive guests at the ninth annual Washington Ball in 1931.

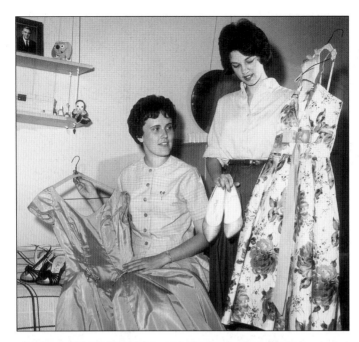

Special occasions called for dressing up. For both men and women, putting together a complete, matching outfit from a small dorm closet could sometimes call for help from a friend who wore a similar size and had similar tastes in clothing.

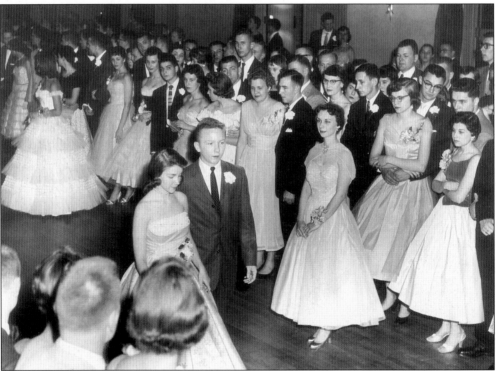

Beauty and popularity contests were a regular part of college life from the 1920s through the 1960s. In one traditional contest, the yearbook staff announced the results of the Old Gold Beauty selection at a spring dance. Here, under the gaze of her fellow students, Old Gold Beauty candidate Jean Bricker is escorted down the floor at the 1957 dance. Full-page pictures of the Old Gold Beauties appeared in the yearbook.

124

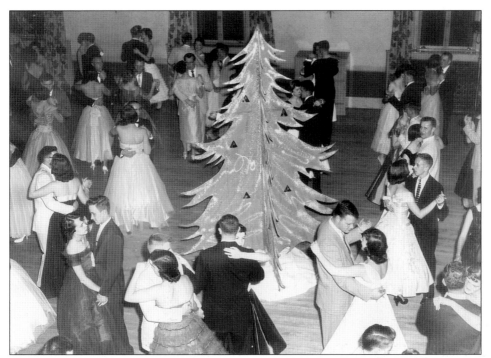

Decorations for this Christmas Cotillion in the Commons ballroom in 1956 included a cardboard tree on the dance floor, evergreen bough swags on the balcony, and mistletoe over the doorways. The 14-piece Rod AaBerg orchestra from Minneapolis provided the music. During the orchestra's intermission, students enjoyed choral numbers sung by Alpha Chi Epsilon and Delta Delta Phi as well as a visit from Santa.

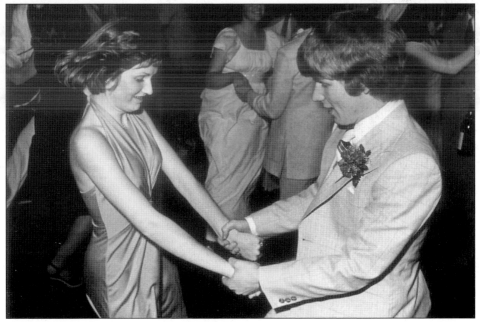

Both clothing and dance styles had changed radically by the time of the Hagemann Hall Formal pictured here in 1979.

These students in 1979 are getting ready to enjoy a Soul Food Lunch during another early spring tradition, Black History Week. Mary Williams prepared the meal that included black-eyed peas, mixed greens, ham hocks, fried chicken, candied sweet potatoes, lima beans, and cornbread.

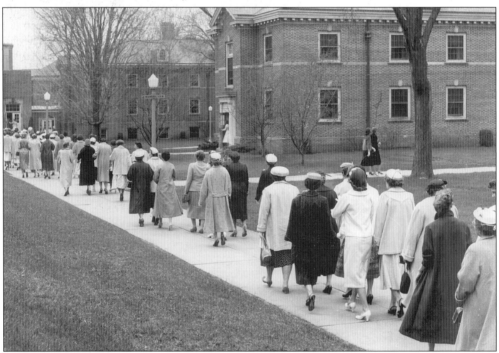

Students traditionally honored their parents with Dad's Day in the fall and Mother's Day in the spring. Mother's Day celebrations often included a student variety show, teas sponsored by campus organizations, and a chapel service. The mothers and daughters pictured here are headed past Bartlett Hall toward the Mother's Day dinner on a chilly spring day in 1957. Mother's Day and Dad's Day evolved into Parents' Weekend, and most recently into Family Fest.

Students have rollerskated on campus for at least 60 years. But in recent years, in-line skates and rollerblades have added new dimensions of speed and maneuverability to this enjoyable form of exercise and transportation. These students are enjoying their skates on a beautiful spring day.

ACKNOWLEDGMENTS

Anyone who writes about the University of Northern Iowa must acknowledge the importance of the three book-length studies of the institution. First, David Sands Wright's Fifty Years at the Teachers College (Cedar Falls, 1926) is a college pioneer's account of the school's first half century. There are many things that we simply would not know if we did not have Professor Wright's text. Second, Irving Hart's The First 75 Years (Cedar Falls, 1951) puts the institution firmly into its Iowa educational and legal background. Third, and most important, William Lang and Daryl Pendergraft's A Century of Leadership and Service (Cedar Falls, 1990, 1995) gives an exhaustive, scholarly account of the school's first century.

I must also acknowledge the generations of photographers who were interested in so many aspects of the UNI community and left a wonderful pictorial legacy. These photographers include William Veatch, H.A. Jordan, H.A. Riebe, George Holmes, Dan Grevas, Bill Witt, and many others. I am grateful that librarians and archivists such as Irving Hart, Fred Cram, A.E. Brown, Mary Dieterich, and Ed Wagner had the foresight to collect, preserve, and describe the photos for the University Archives in UNI's Rod Library. The images featured in this book, all from the University Archives, represent less that one half of one per cent of this outstanding collection. I am grateful to the University of Northern Iowa and the Rod Library for allowing me to use photos from this collection for this publication.

Many helped directly in the preparation of this book. President Emeritus J.W. Maucker; Professors Emeritus Martha Holvik and Tom Ryan; University Carillonneur Bob Byrnes; President Seerley's grandson Homer Culley; and Rod Library Special Collections staff Susan Basye, Heather Bird, Stephen Territo, and Sara White all provided generous help on photo identification. I want also to acknowledge Dean Herbert Safford and Professor Katherine Martin for helping me clear bureaucratic hurdles. My sharp-eyed proofreaders included my wife Elizabeth Peterson and my daughters Julie Qidwai and Amy Peterson. My editor Carrie Radabaugh patiently explained how to fit my thoughts into book form.

With all of this help, it should be clear that any remaining errors must be mine.

Gerald L. Peterson
March 21, 2000